Rare Flesh

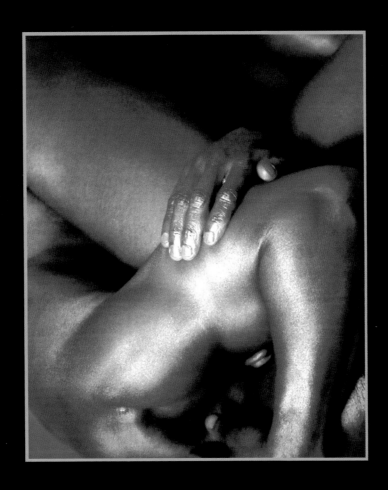

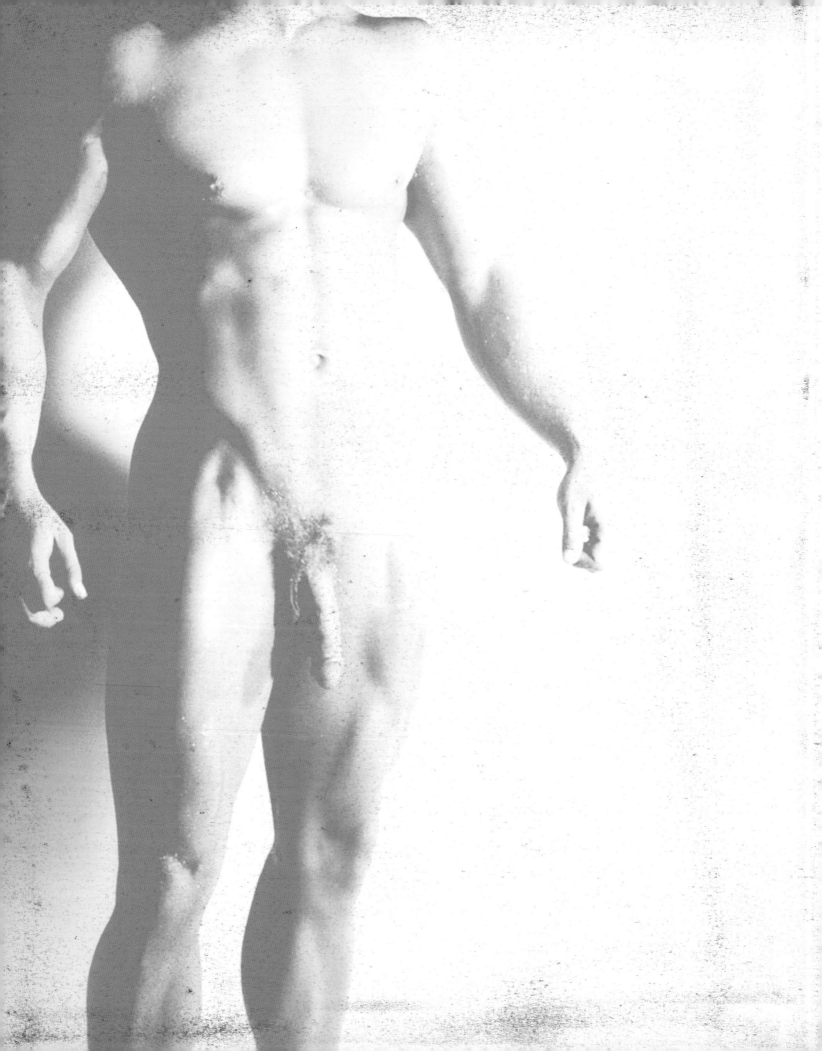

Rare Flesh

David E. Armstrong

text by Clive Barker

Universe

Here is laid

A strange theatre.

Dancers,

Beasts,

And exhibitionists

Parade upon a painted stage,

Their heads

And hearts

Gleaming in the wet light.

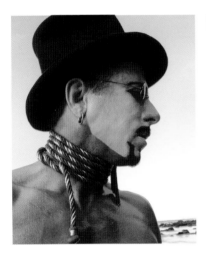 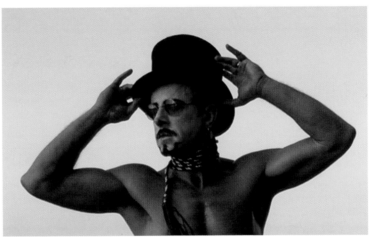 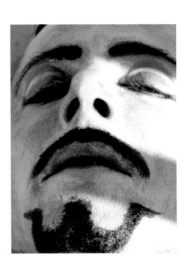

for Clive

Foreword
Fetish and the Work of David E. Armstrong

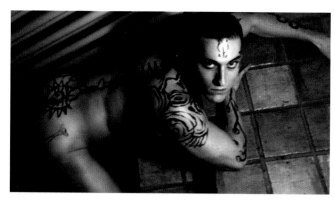

I first met David Armstrong at his and his husband Clive Barker's home back in 1999. Upon meeting me, David was quick to tell me how he was such a fan of my own work, which was flattering. Then Clive suggested that David show me some of his photographs. "You guys have a lot in common," Clive said.

At the outset David was too shy to take out his portfolio, but we got to talking, and he eventually took me down to show me his studio. From there it was not long before he felt comfortable enough to bring out a collection of photographs.

I was shocked by their intensity; my admiration was immediate. He took me through a series called "Tar Babies"—hundreds of images of nude men, many clearly aroused, covered in shiny, black grease paint. The series turns the human form into a solid shape or shadow: the bodies become erotic and horrific at the same time. By photographing a variety of men encased in black, David has brought out their raw power, and in a sense, he has taken them back to their natural state. By doing so he has empowered his subjects with ritual and taboo. It is like looking at images that are private and slightly sinister. Almost forbidden.

In recent decades the male nude as an icon has come a long way. In the early part of the last century, photographers like George Platt Lynes and painters like Paul Cadmus produced work that was much more graphically sexual than anything that had been allowed in previous generations. But they kept much of their homoerotic material under wraps, selling the work only to a very limited audience, if at all.

Similary, the photographer Pierre Molinier produced several series of fetishistic self-portraits through his adult life, but the work was not acknowledged until after he committed suicide. His estate went to his sister, who destroyed some images and suppressed many others for years to come.

But things have changed. Photographers like David are no longer hiding their erotic and fetishistic visions away. I use this term *fetish* with pride.

The dictionary defines *fetish* as follows: 1) Fixation of erotic interest in an object or part of the body; 2) Any object of special devotion; 3) An object possessing magical powers. Magic, devotion, power. These are the ideas that underpin David's photography and deepen the photos' eroticism with a host of other echoes and meanings. There is a sense that we are looking in on private ceremonies.

We are getting a glimpse of these beautiful men engaged in erotic games, dances, and perform-

ances. The male body, even photographed as lovingly as David photographs his models in these rituals, can still stir up strong feelings. But the time has come to liberate photography from such anxieties.

And their erections are the fleshly counterparts of one of the most ancient of symbols—a central part (some would say the most central part) of the iconography of human desire and divinity from the earliest of times.

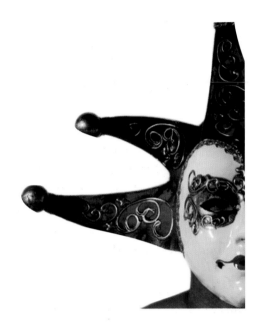

Perhaps the most intimate images are those that David made of his husband, Clive. The best results in photography occur when the photographer knows his subject well. With David's images of Clive the intimacy is apparent. You can see that the subject will do anything for his portraitist. In turn, the portraitist brings out the sensuality in the subject that borders on otherworldly.

So much of the art and craft of photography lies in capturing the definitive moment. David not only captures moments, he also shows us a way forward. He is an artist who sees with his spirit beyond the limitations of his age, and in so doing claims a permanent place in the art of our time.

—Rick Castro
Los Angeles, August, 2002

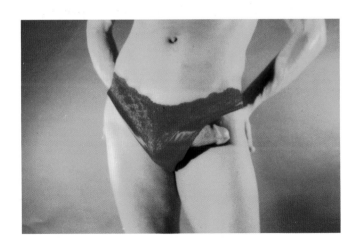

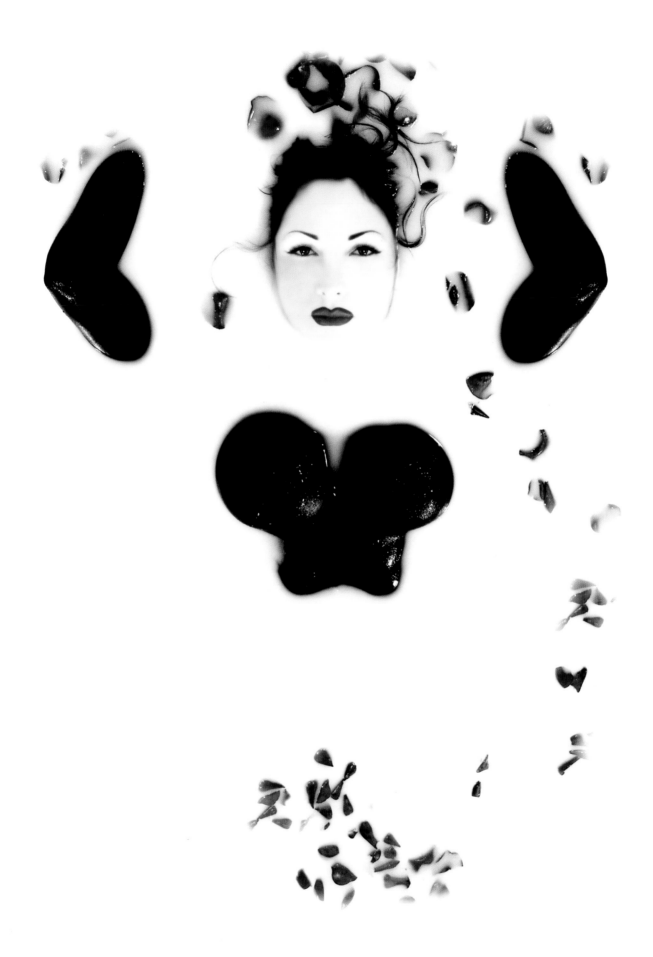

Mater Salvatoris,

Black Madonna,

Who is Elizi Dantō,

Bride goddess of the priests of Voodoo,

Who is Durga, the death-bringer,

Who is Maria, the life-bringer,

Who is all bright things

That are born out of darkness.

And return into darkness.

Show me a vision:

Show me the forms that men can take

So that I might choose a vessel for love.

All Channels Are Open.

The locks are shattered; the seals melt and fall away. In every part of the planet, miraculous transformations begin. Fantastic forms rise up out of the earth and dictate their life stories. Animals demand paper and pen. The word is forgiven its trespasses and begins again.

All Channels Are Open.

Every furrow is fertile. Every conduit is foaming. The passages of tombs are drawing in breaths of living air and expelling the spirits of the dead upon them. They come back to us carrying fire, to burn away the bloat of shame.

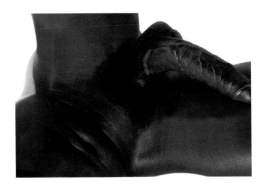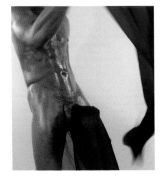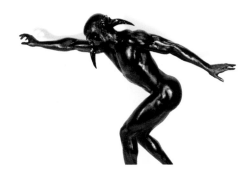

All Channels Are Open.

All corrupted and censored texts are returned to their intended states and are reading themselves aloud. All defaced edifices, carved with divine instruction, are made whole again. All statues, broken or unsexed by righteous parties, are remodeled from their own dust. All artifacts buried for shame's sake—particularly representations of the Holy Cunt and the Holy Cock— are unearthing themselves.

All Channels Are Open.

The rhythms of intercourse are being beaten out on the stratosphere. Several witnesses report the sun's prominences have taken the form of human bodies, rising up off the photosphere and burning away. The questions sent into space by unmanned probes are answered with obscenities and love songs.

All Channels Are Open.

Rains of phalluses fall in the Pacific, their imminence indicated by the surfacing of innumerable squid. On the shores of the Red Sea a man claiming to be the Onan, the son of Judah, appears in the company of a thousand life-forms grown from his spilled semen. Female martyrs are appearing in the streets and squares around Rome and converge on the Vatican, caressing their wounds. The dome of St. Peter's runs with milk.

All Channels Are Open.

In Jerusalem, in Ephesus, in Salt Lake City, hermaphrodites are appearing, locked in sacred coitus.
In kitchens across the world, children masturbate freely, while their mothers bake bread
in their fire-filled wombs. In the slaughterhouses, the killing stops.

All Channels Are Open.

In places where the lonely congregate, or wander to plan their deaths, chants and prayers are being
disseminated, which will summon lovers. Some will be imaginary, some real;
there will be no significant distinction.

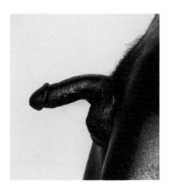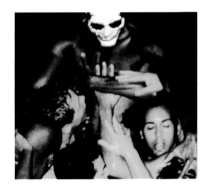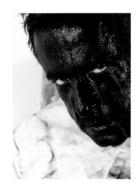

All Channels Are Open.

In the temples, the priests go from their altars, tearing off their stale robes, looking for women,
for boys, to show them bliss they have denied themselves. Sadhus forsake their standing places, and
hobble to the nearest brothel. In the seats of government, and in the courthouses, the
lawmakers convulse, and fall on the floor spewing their confessions: the names of
their mistresses and the names the mistresses call them by.

In the madhouses, a sudden lucidity.
The shadow on the cave wall takes on a life of its own, and comes to wake us with a kiss.

All Channels Are Open.

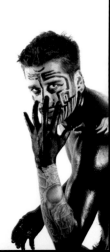

There is no reason not to begin.

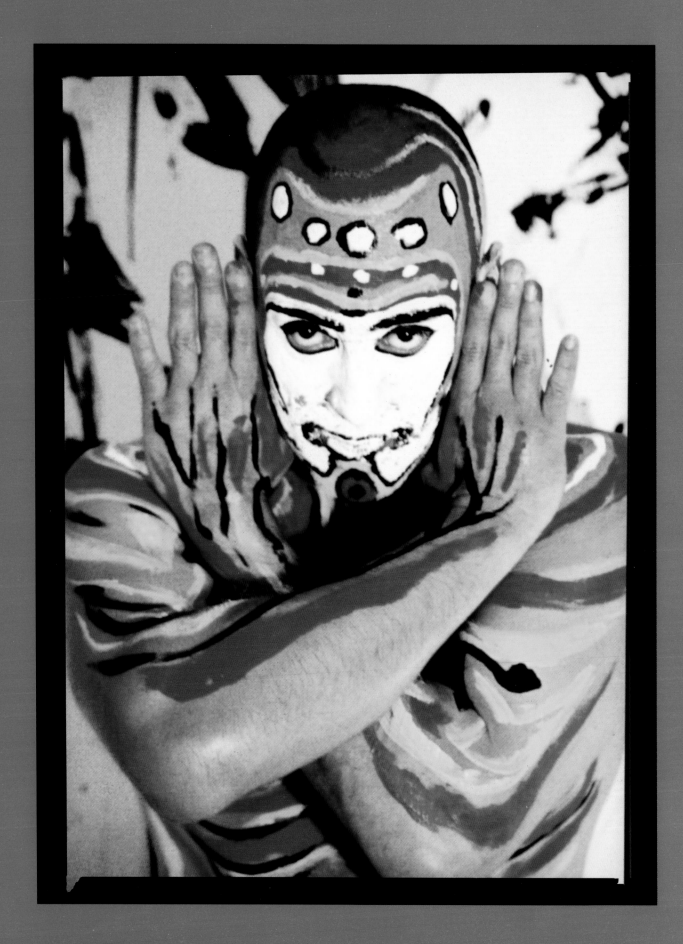

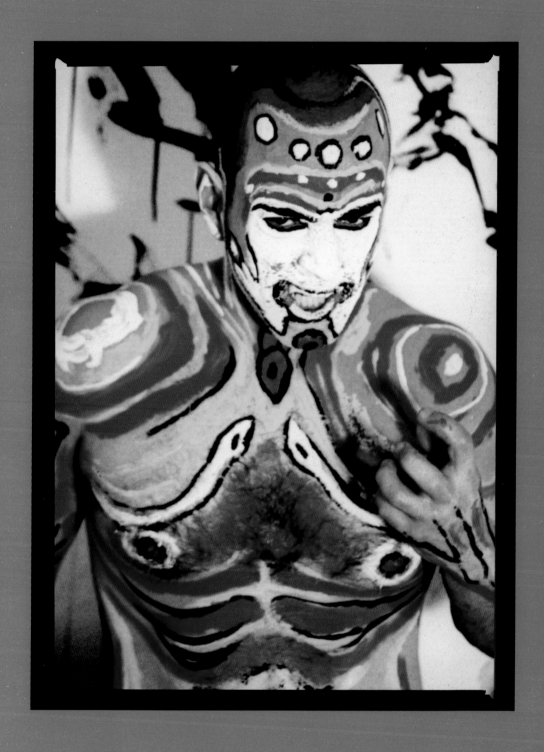
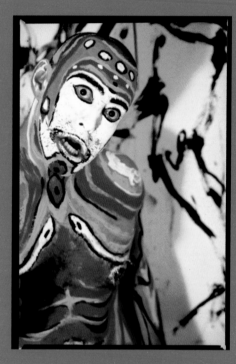
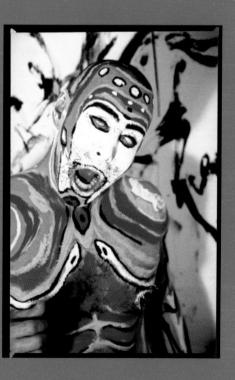

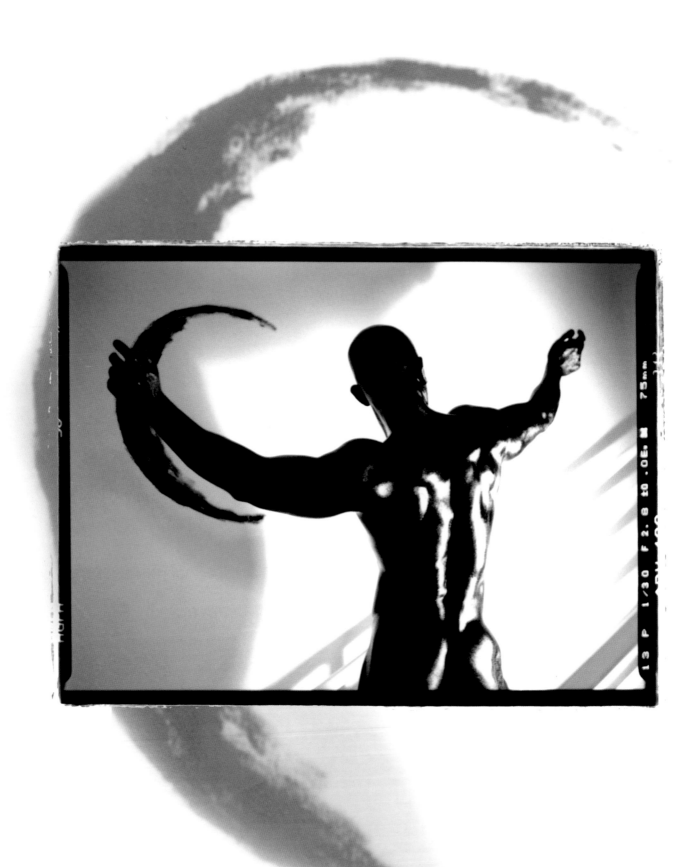

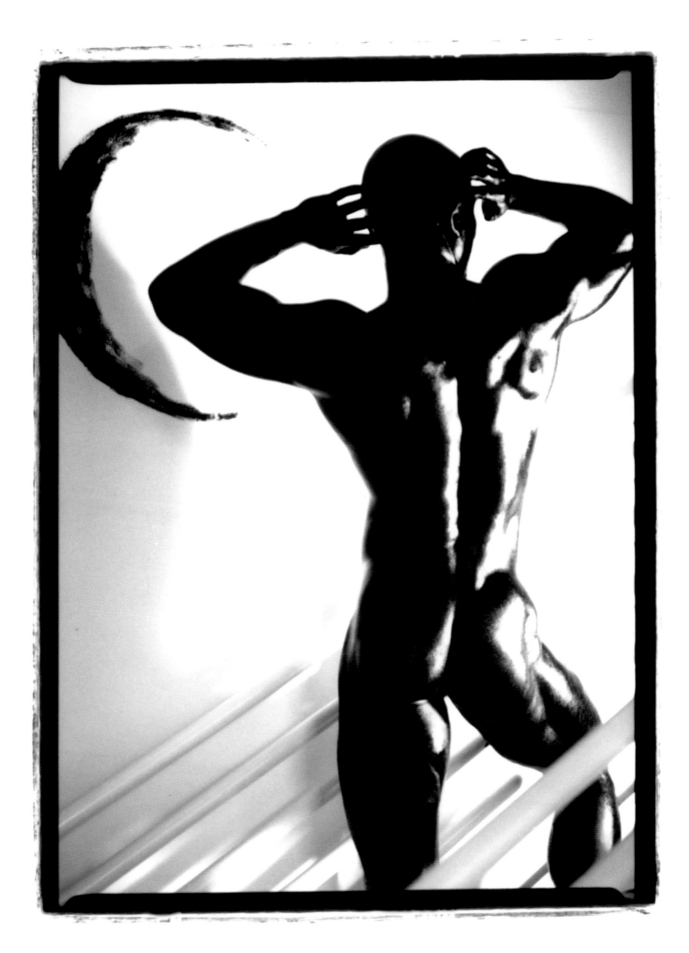

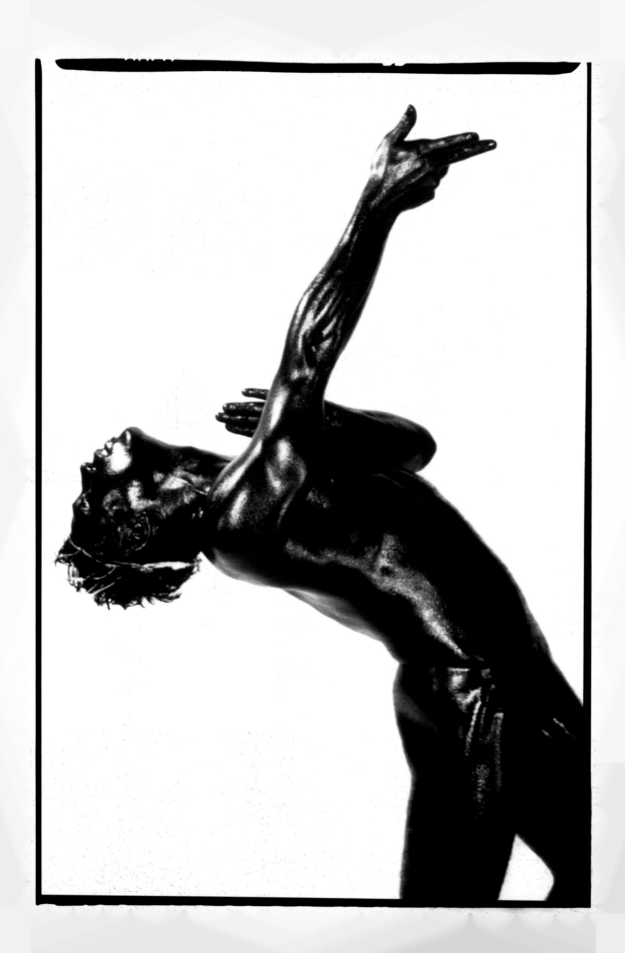

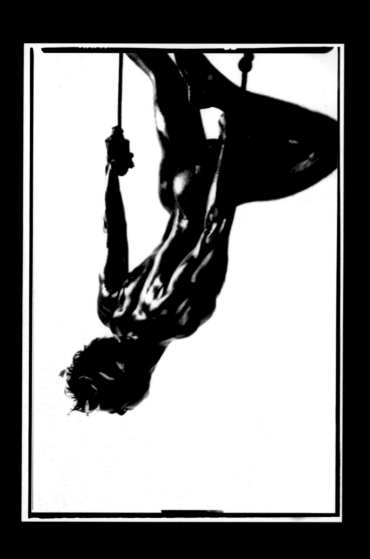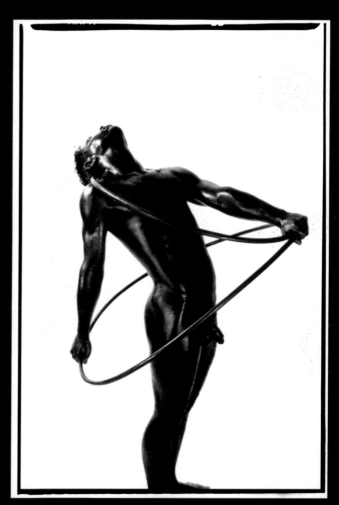

The story goes

that Plato and Socrates were together

walking the streets of Athens

when the youthful Plato drew

his mentor's gaze towards

some flawless youth.

Please, don't remind me, the old man said,

I have waited a lifetime

to be free of that distraction.

(Or words to that effect.)

I wonder:

will it really feel that way?

Like a weight lifted from some finer self?

Socrates had a mighty mind

nourished by the beauty of abstracted things.

But when age takes desire from me,

what will be left

to trouble me into wondering

what my soul did

on its way to oblivion?

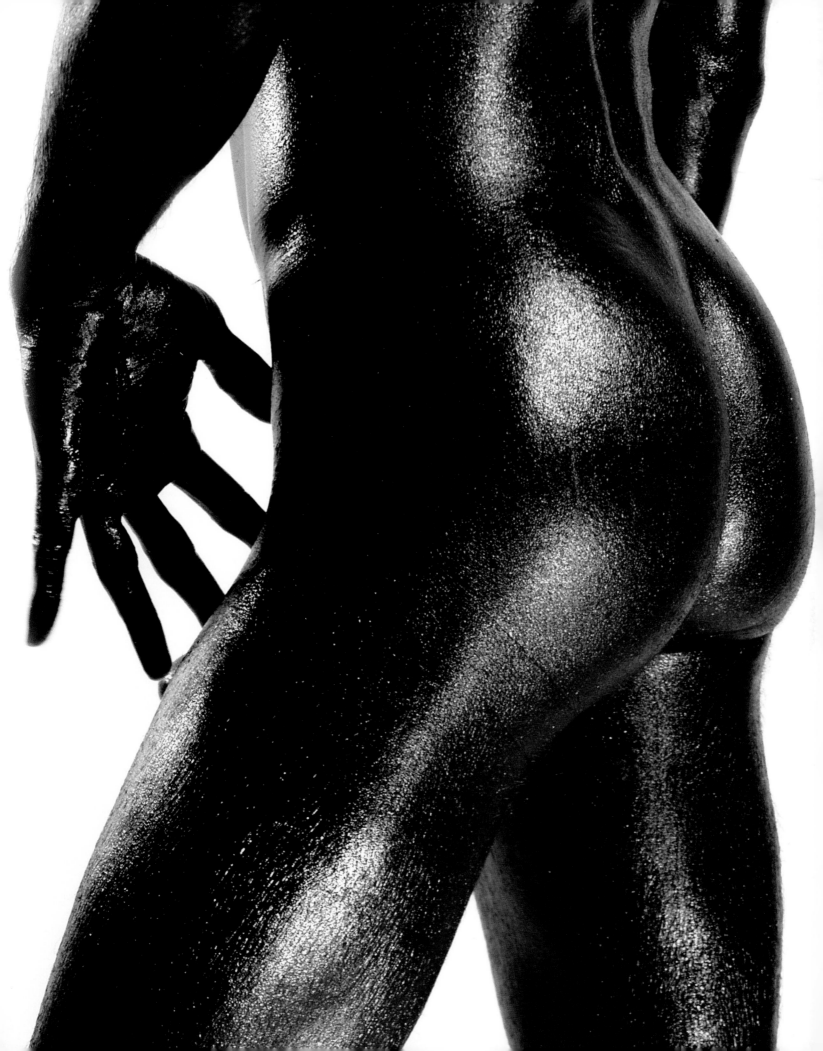

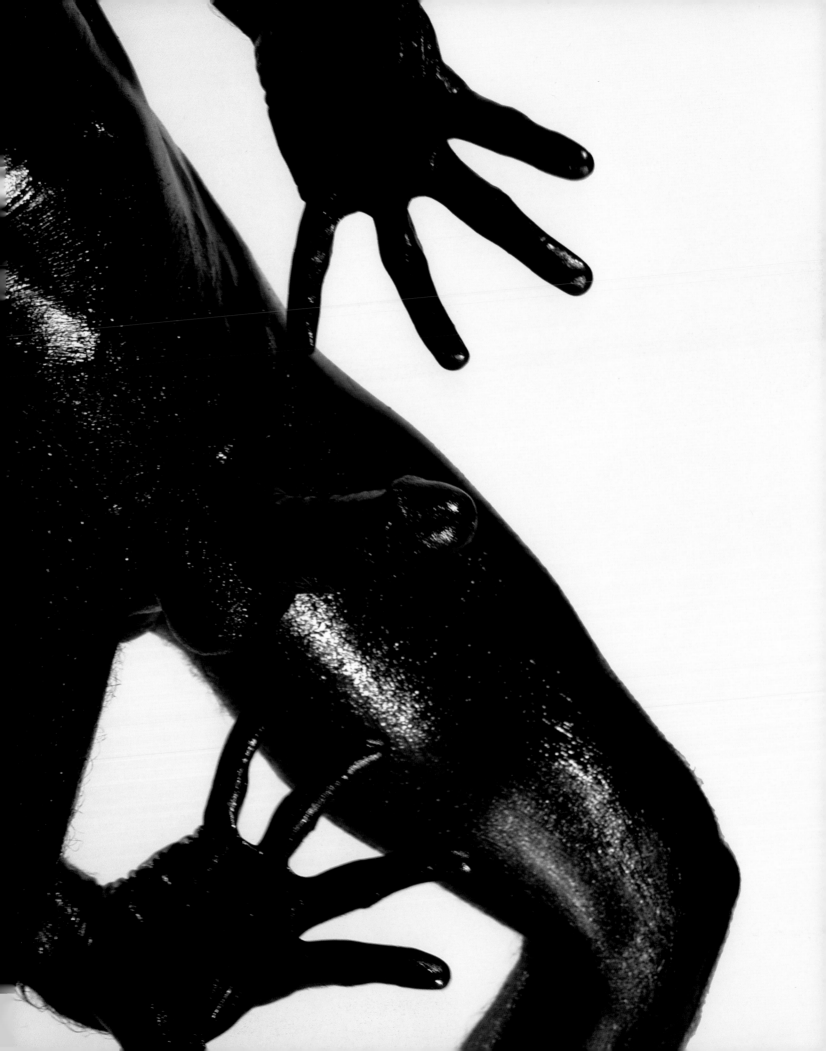

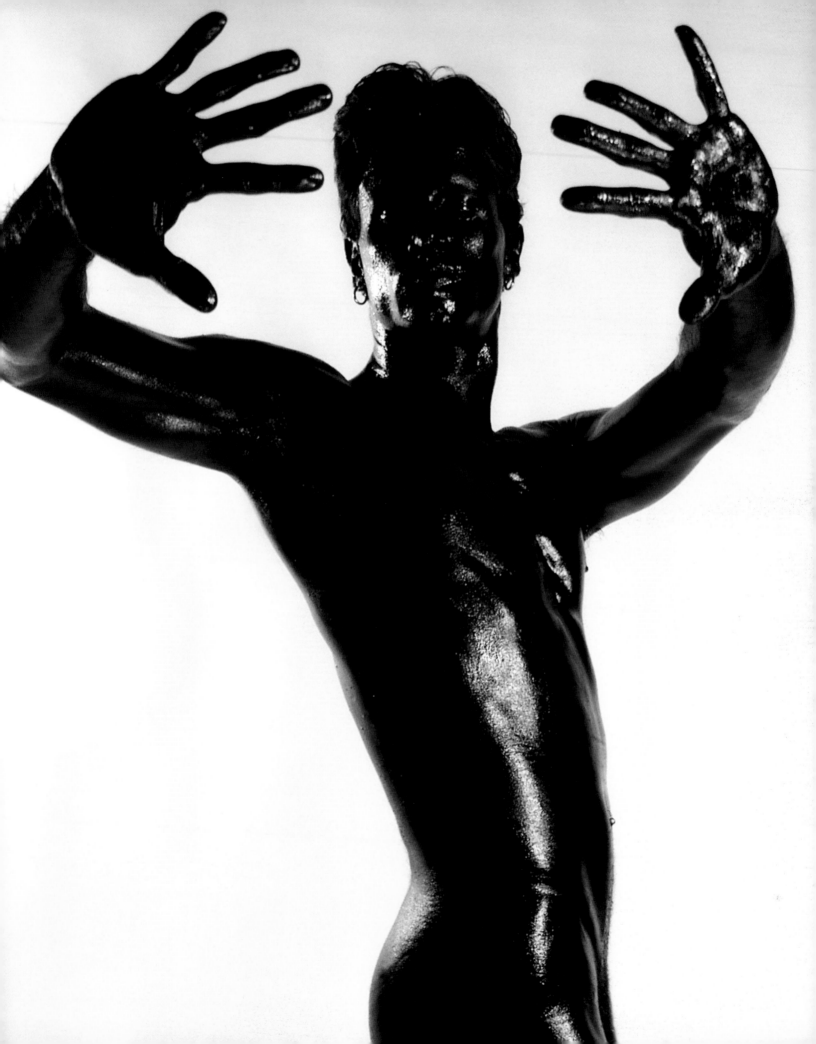

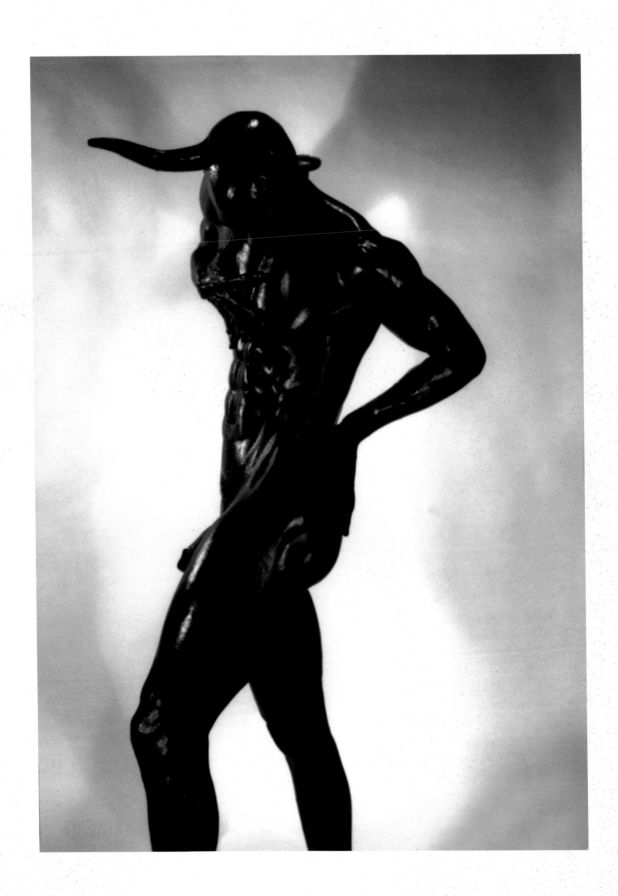

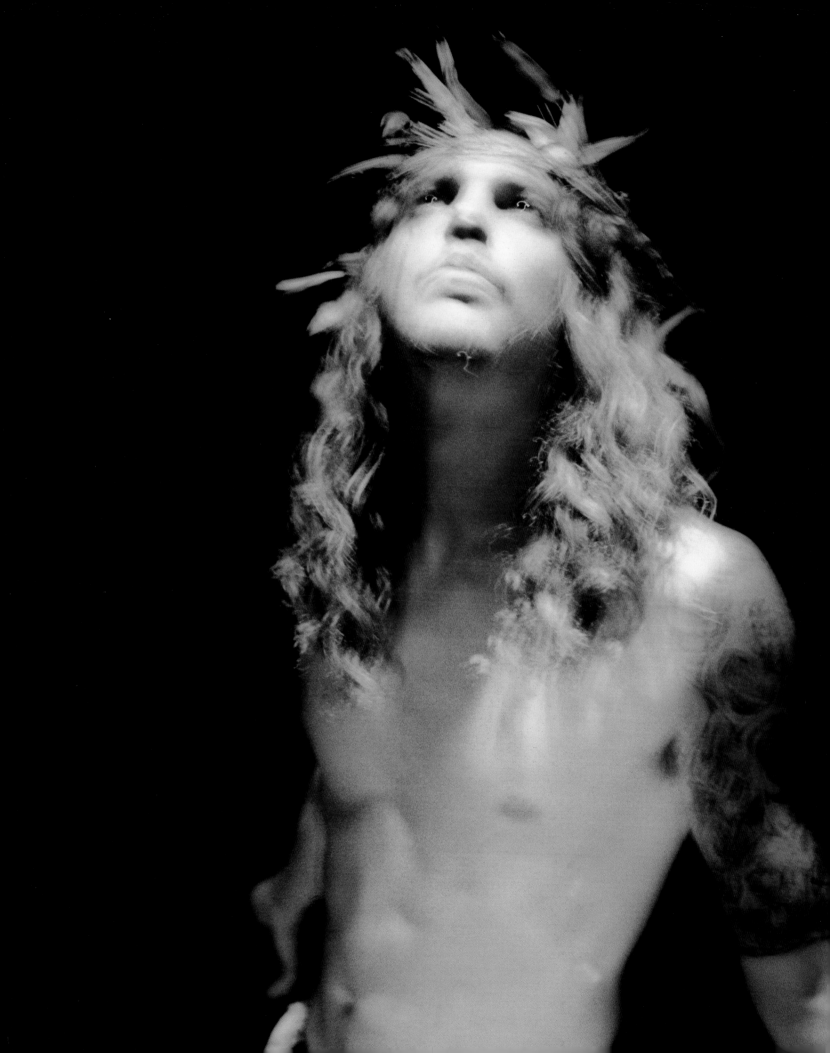

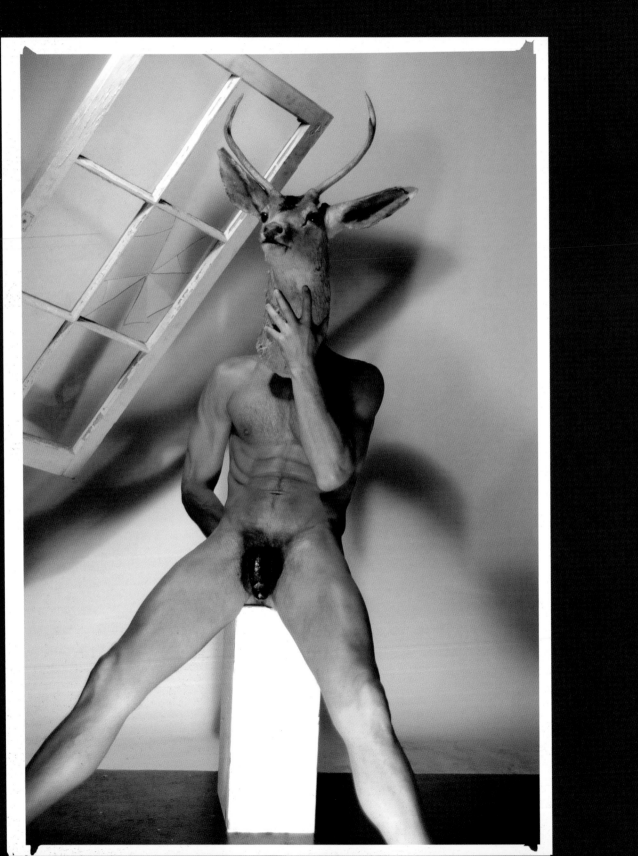

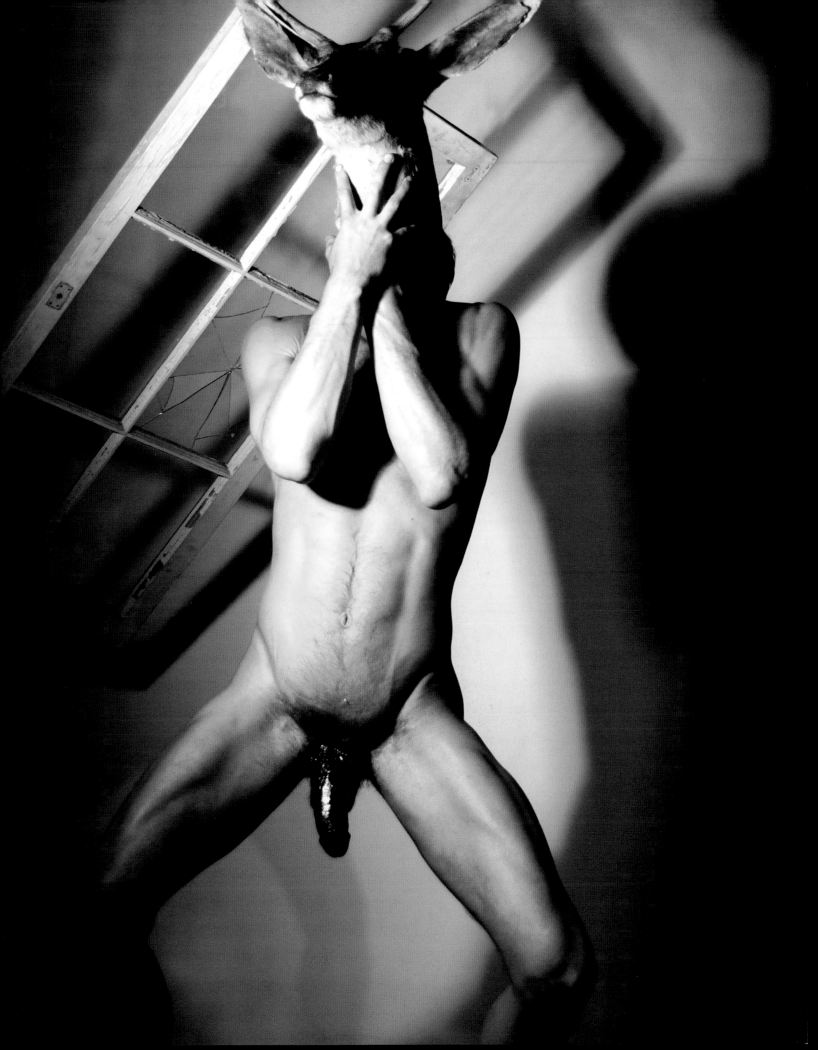

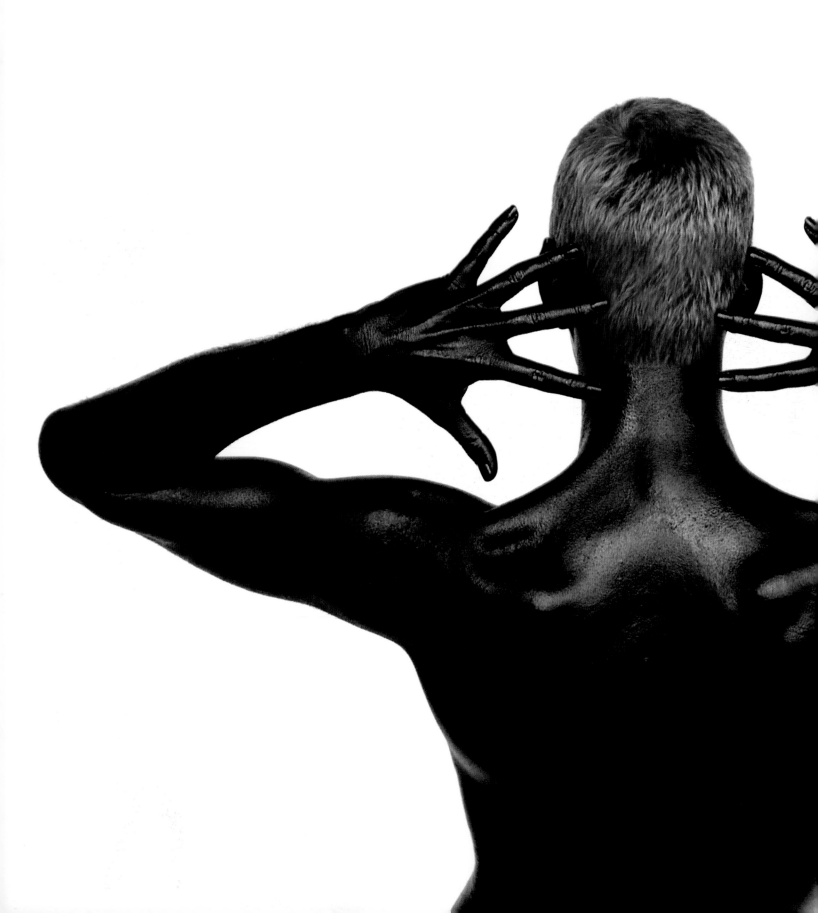

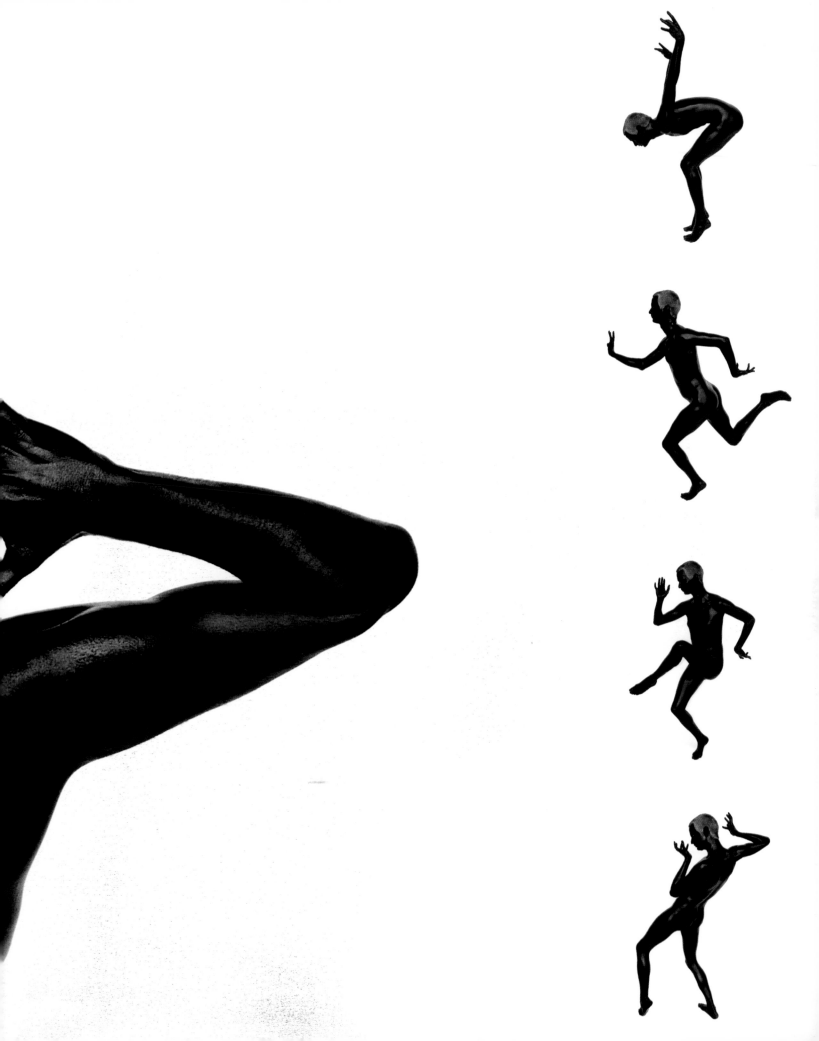

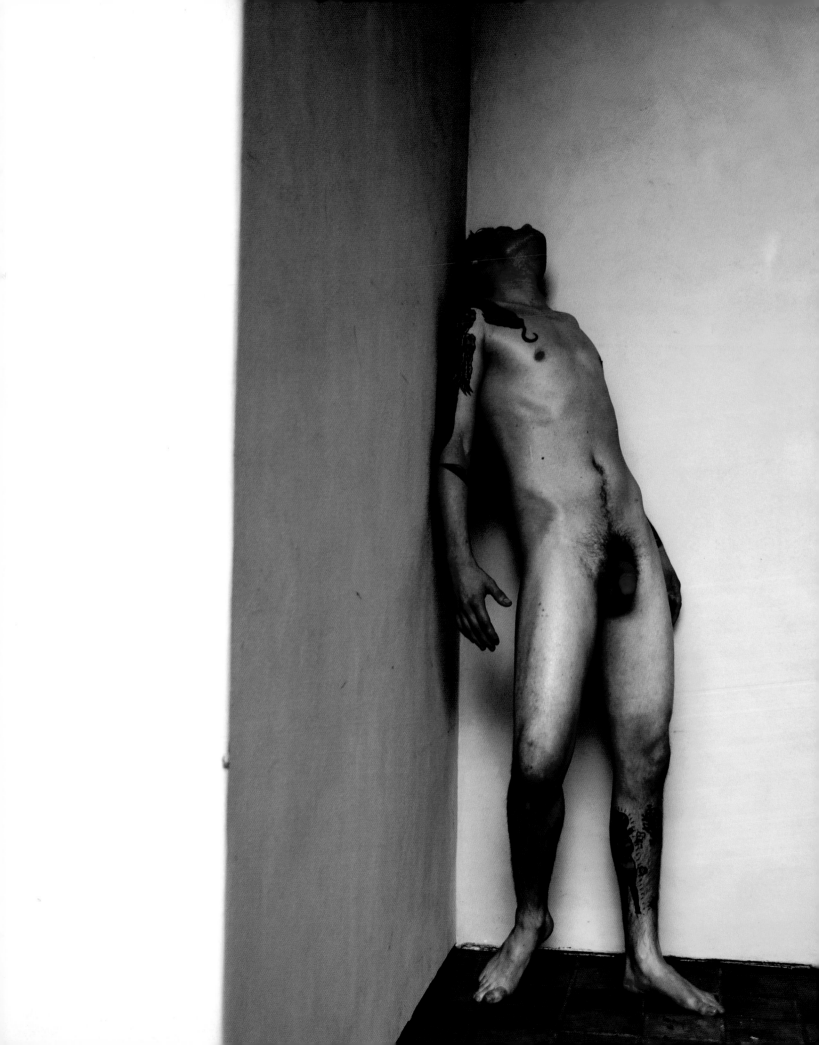

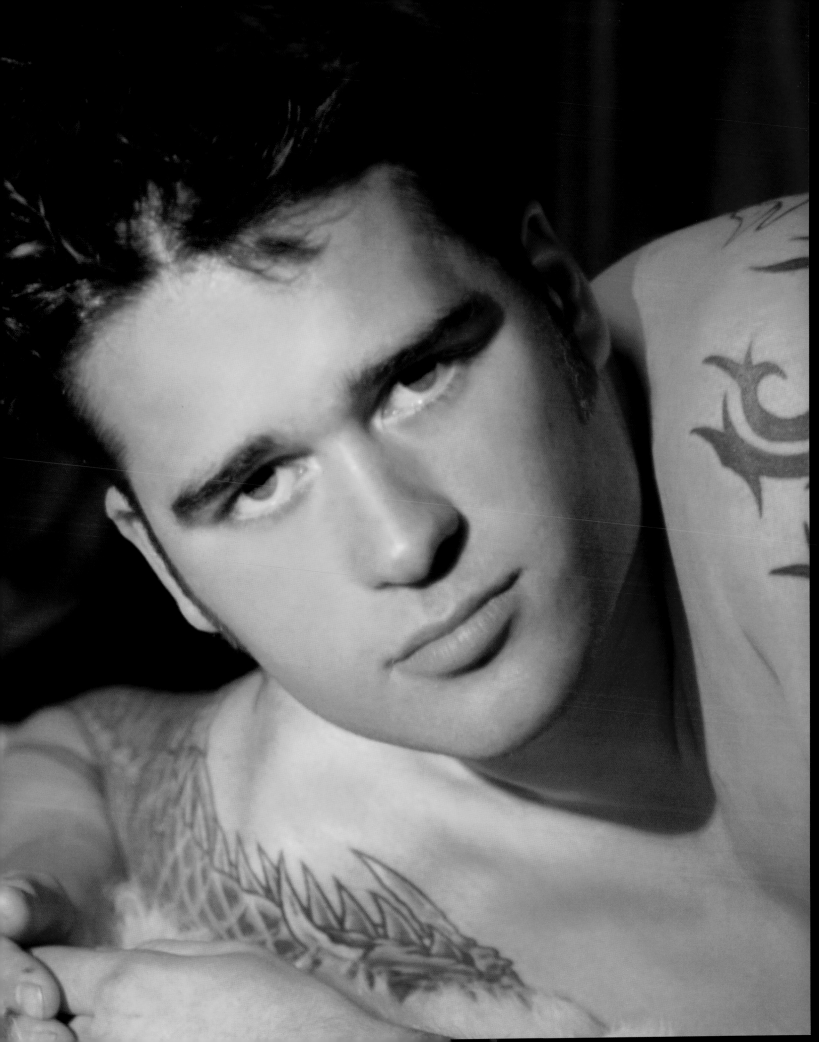

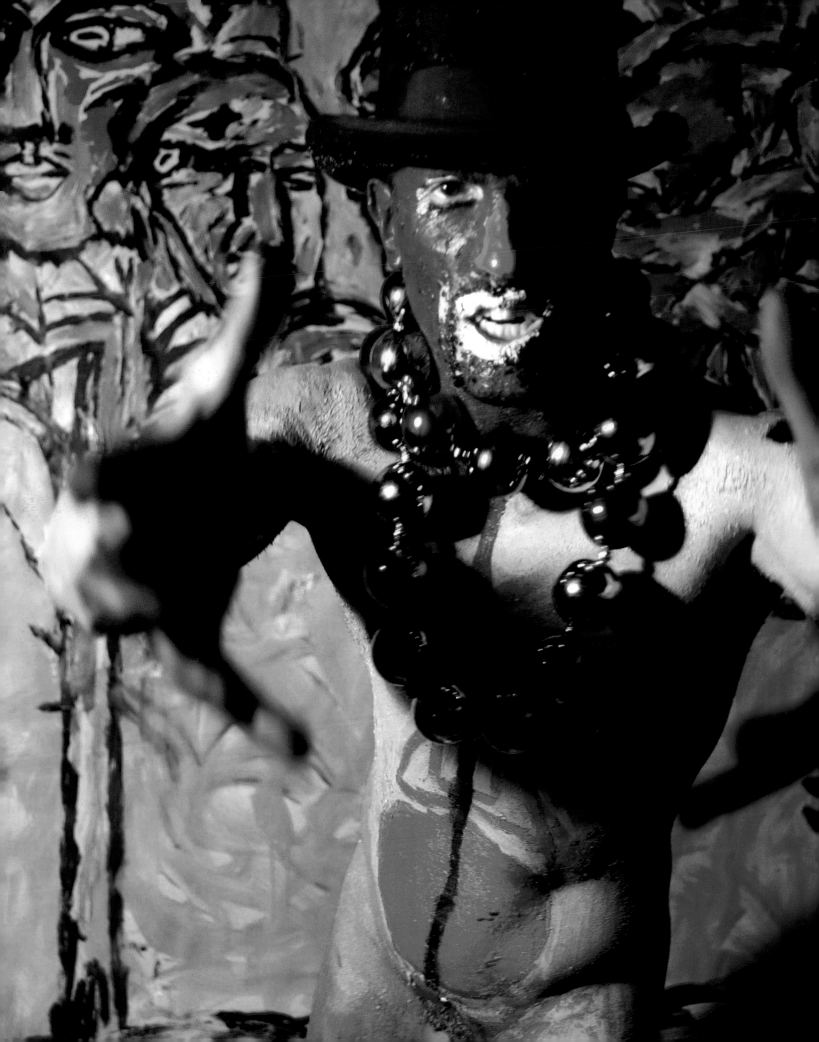

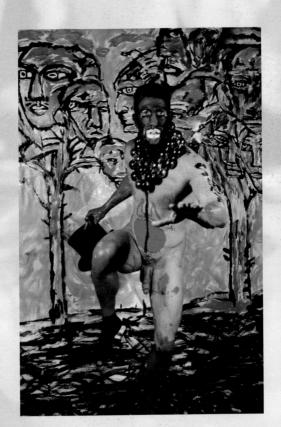
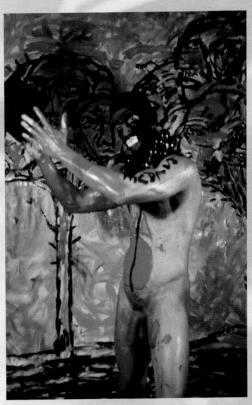
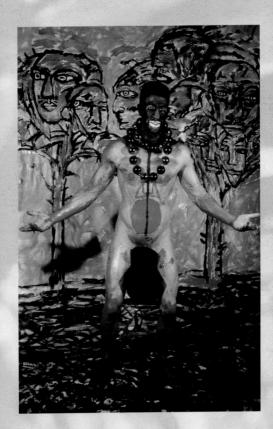

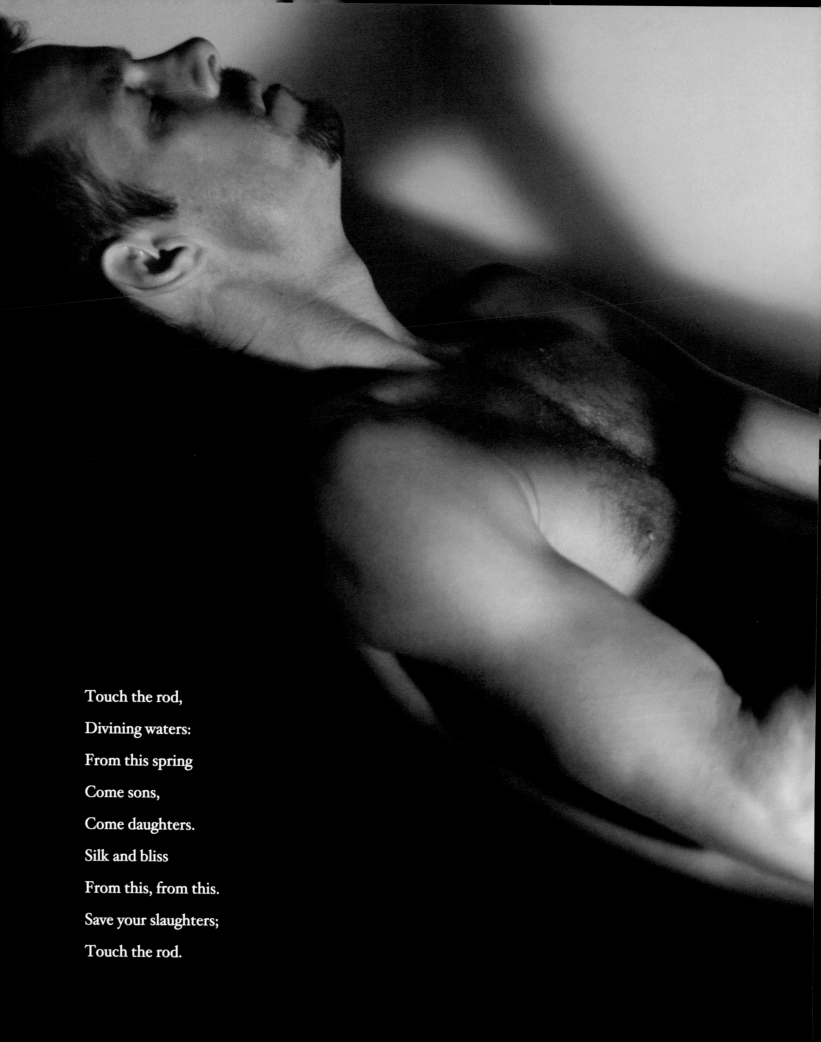

Touch the rod,

Divining waters:

From this spring

Come sons,

Come daughters.

Silk and bliss

From this, from this.

Save your slaughters;

Touch the rod.

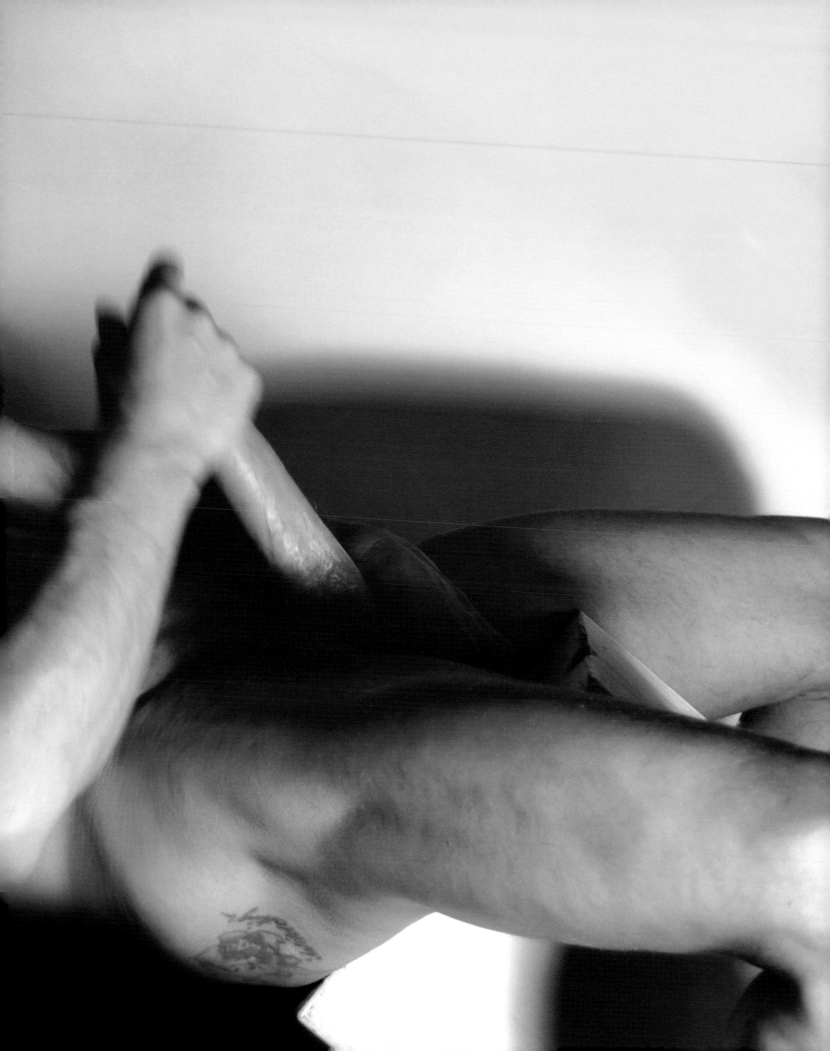

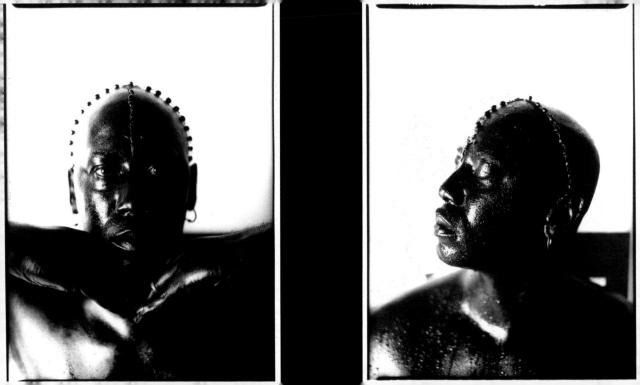

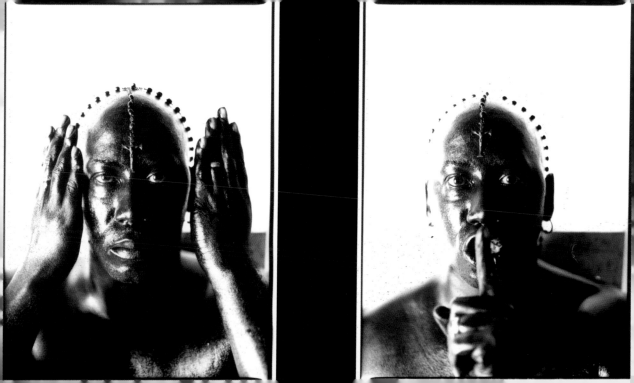

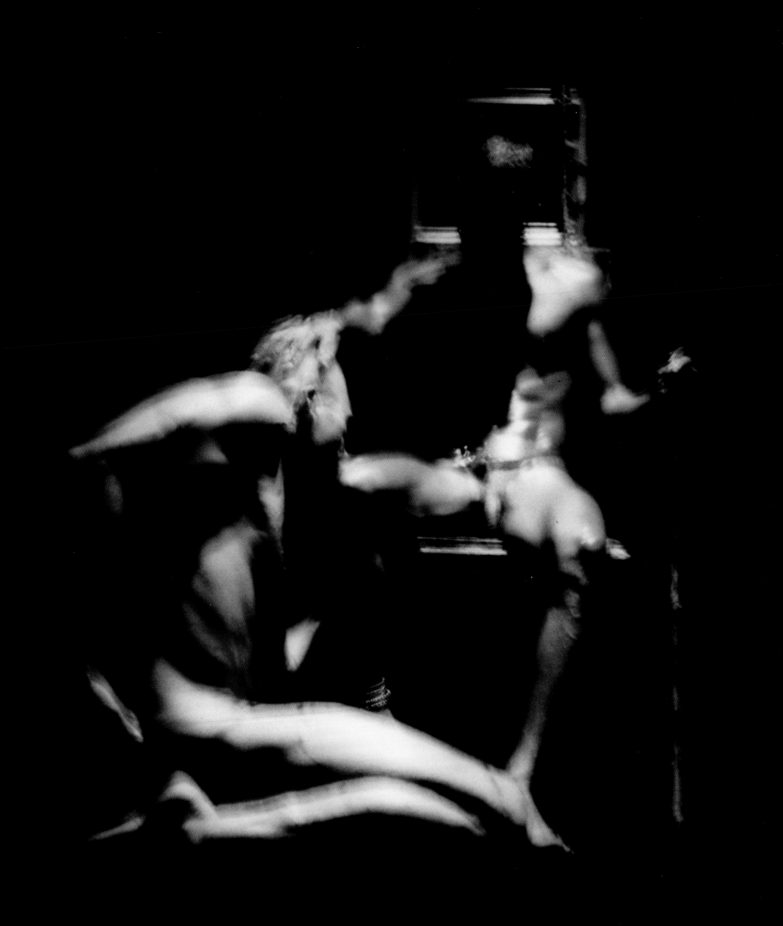

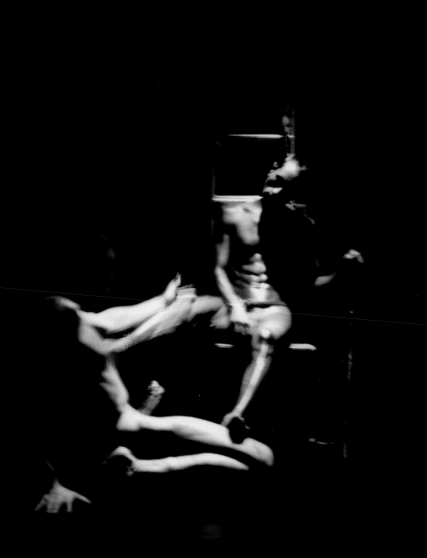

Until the beginning comes,

Do not be afraid.

Until the curtains part,

And the first notes are struck,

Do not hold your breath.

It'll only make you light-headed.

Please be certain:

All is well with the world,

Though it may not seem so.

These fires, these frights, these furies

Are only dramas left over

From the last epiphany.

There is no harm in the turmoil.

The griefs will wash off,

At the speaking of a word;

All will be made well.

And this time,

According to the certain calculations,

The grim wheel will cease to roll.

This time, nothing will end again,

Except beginnings.

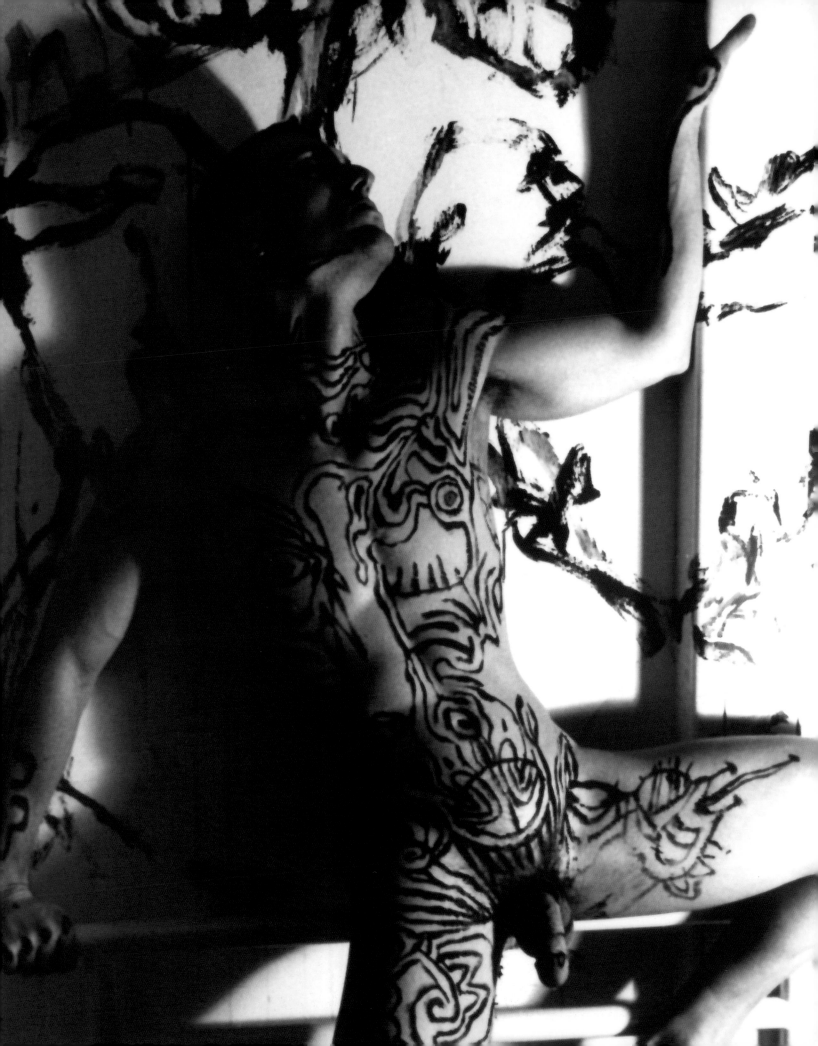

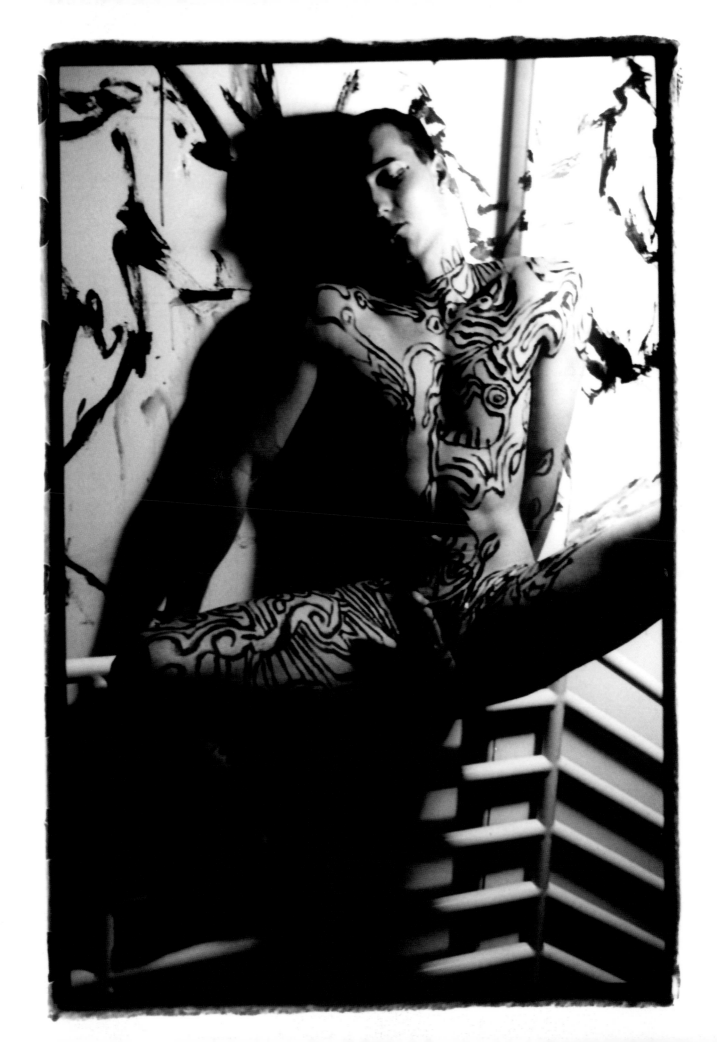

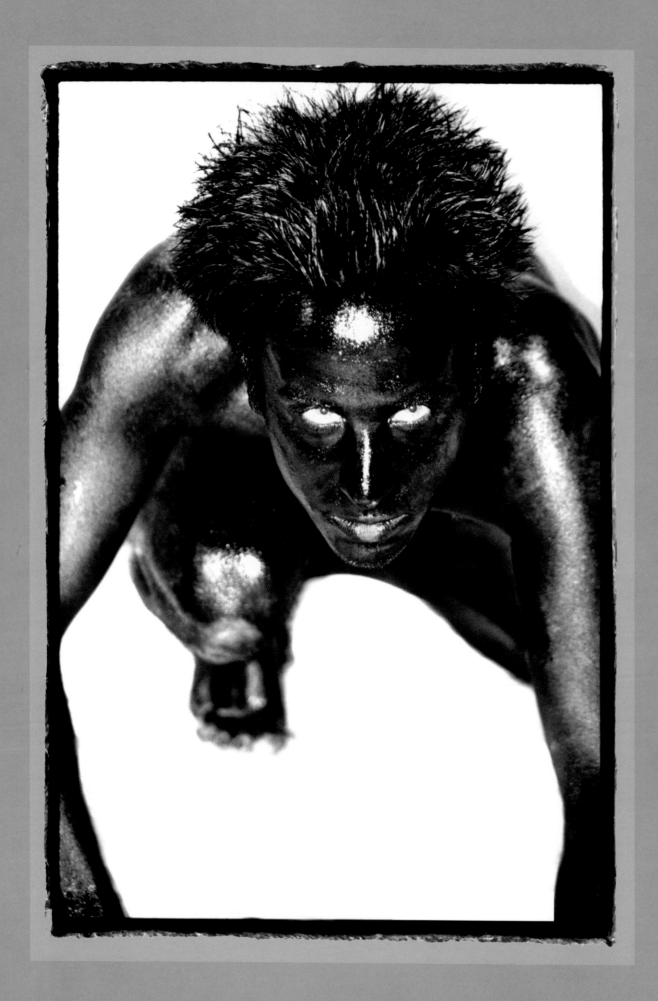

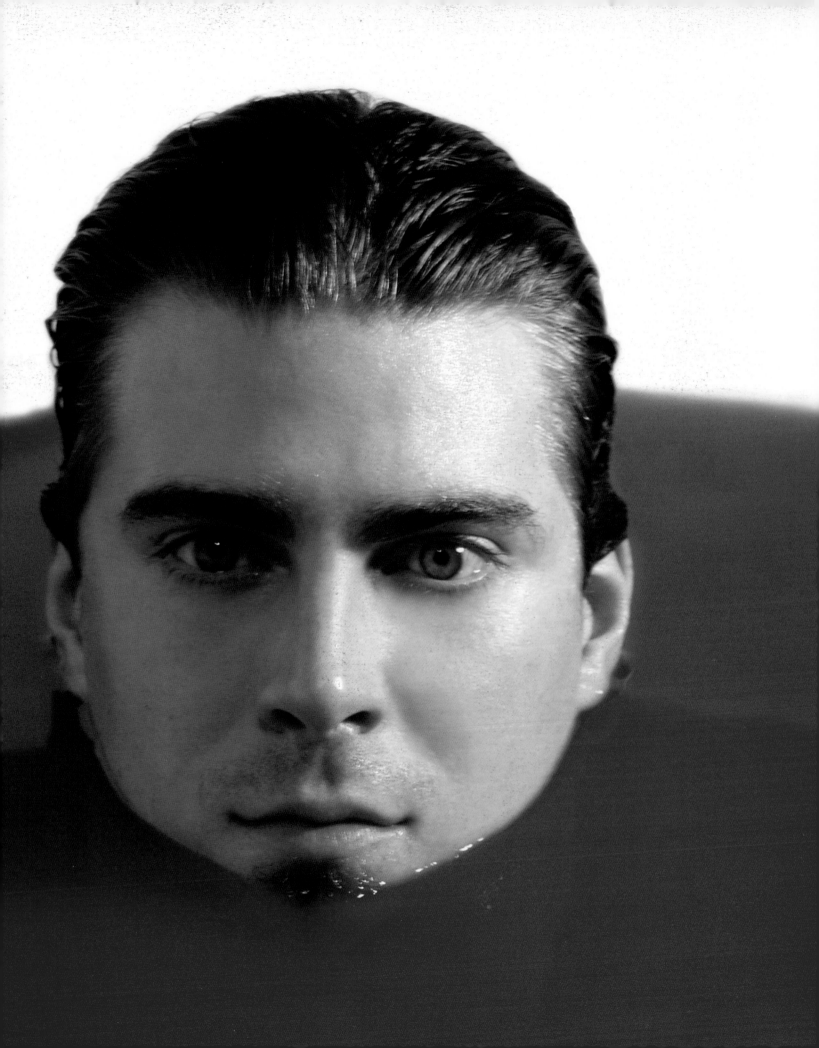

I knew an ardent Communist once

(a theatre director, actually,

back in the days before the Wall fell

when the only way to be employed

in certain quarters

was to be to the left of Lenin)

who could only achieve

any kind of sexual arousal

when beneath the heels

of a mock-fräulein

dressed in something Nazified.

Sometimes nature is even crueler than politics.

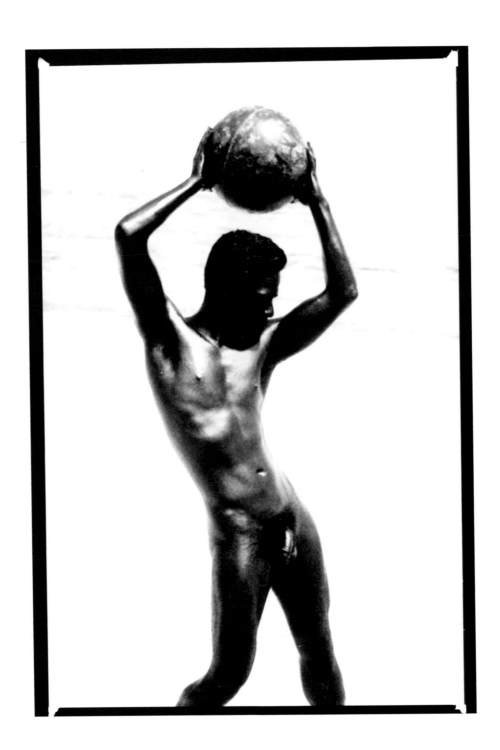

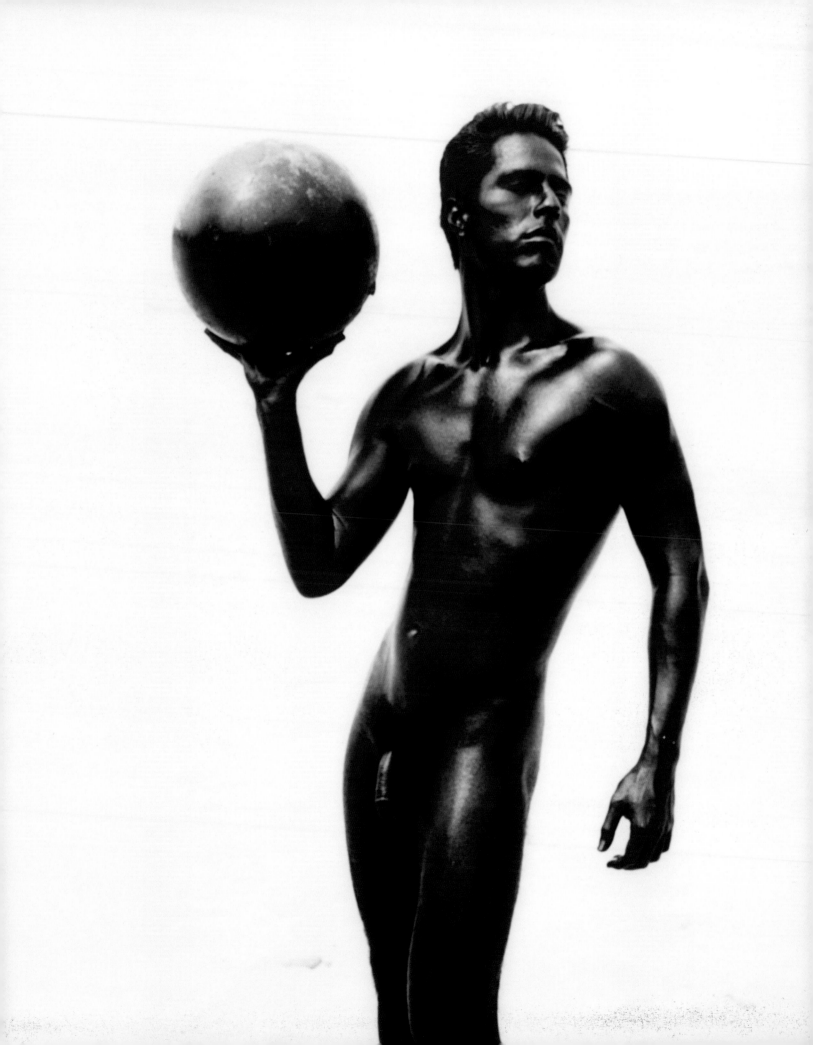

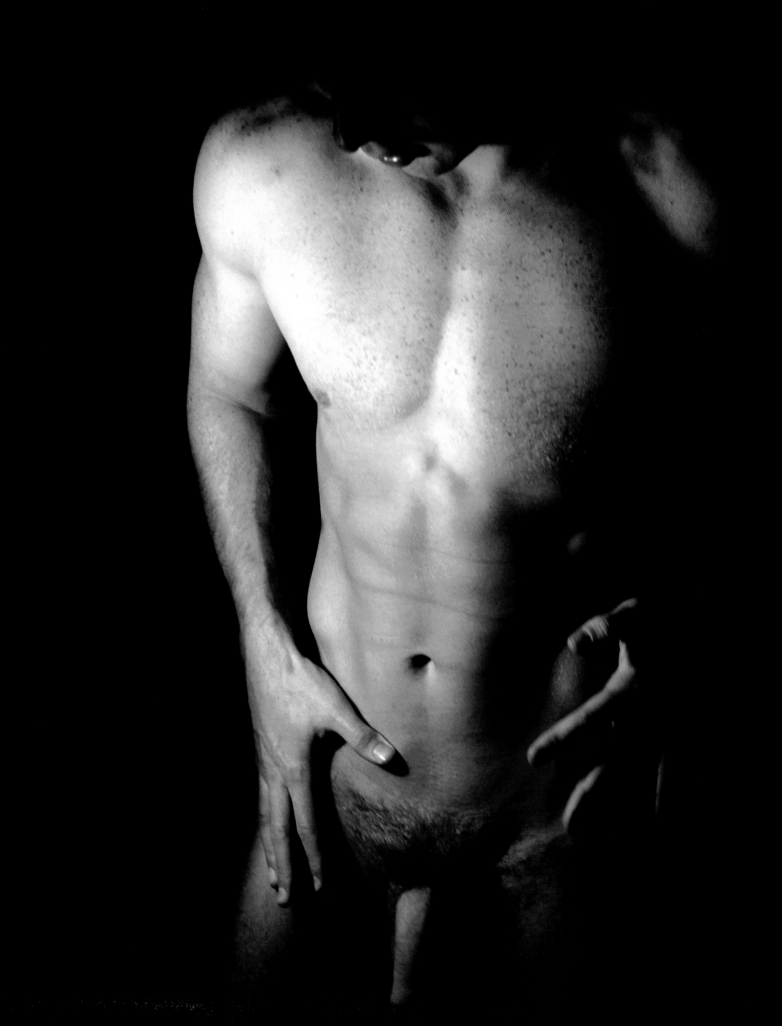

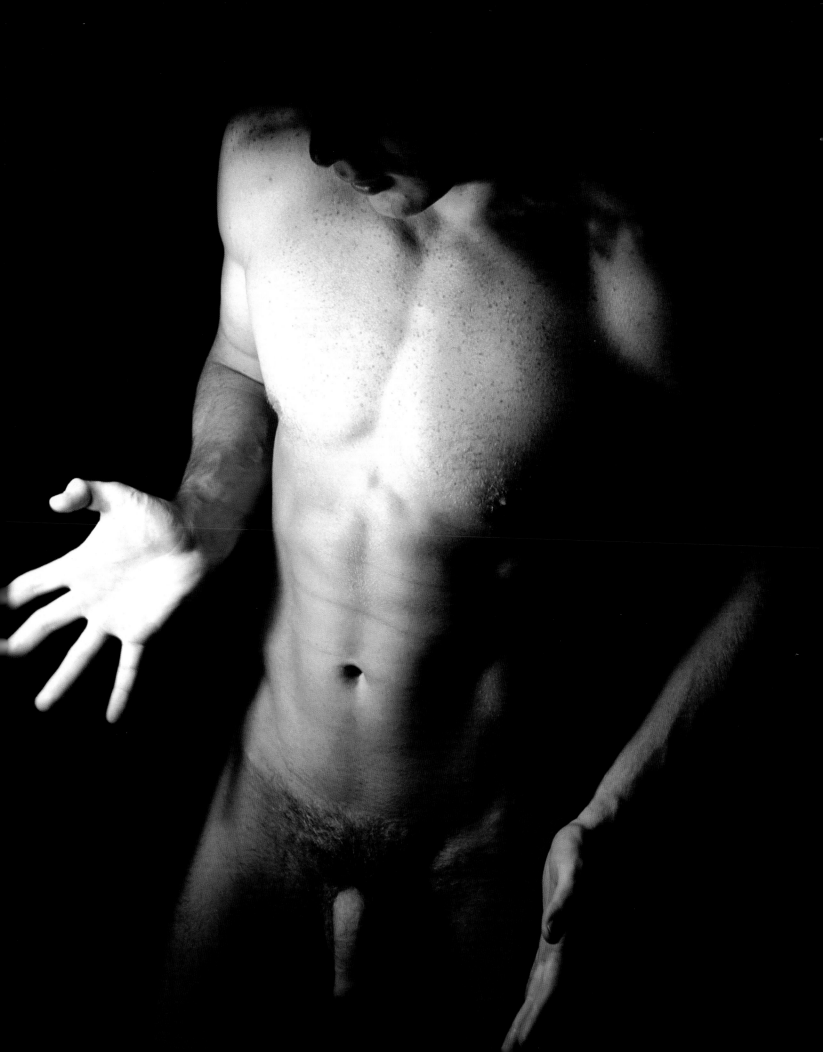

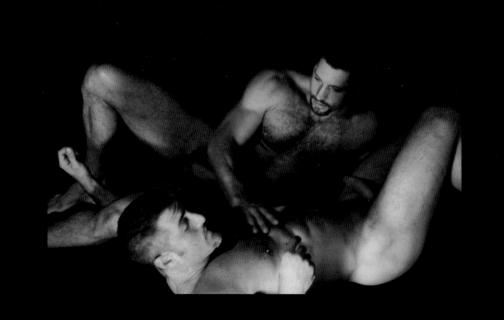

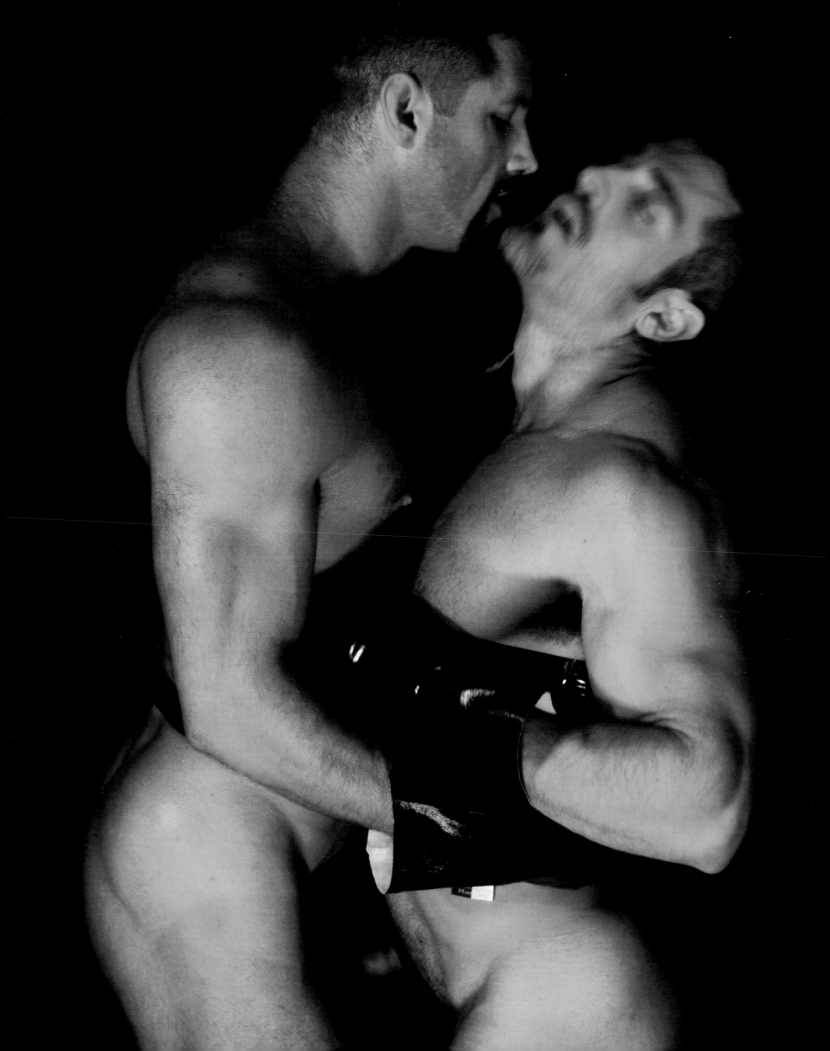

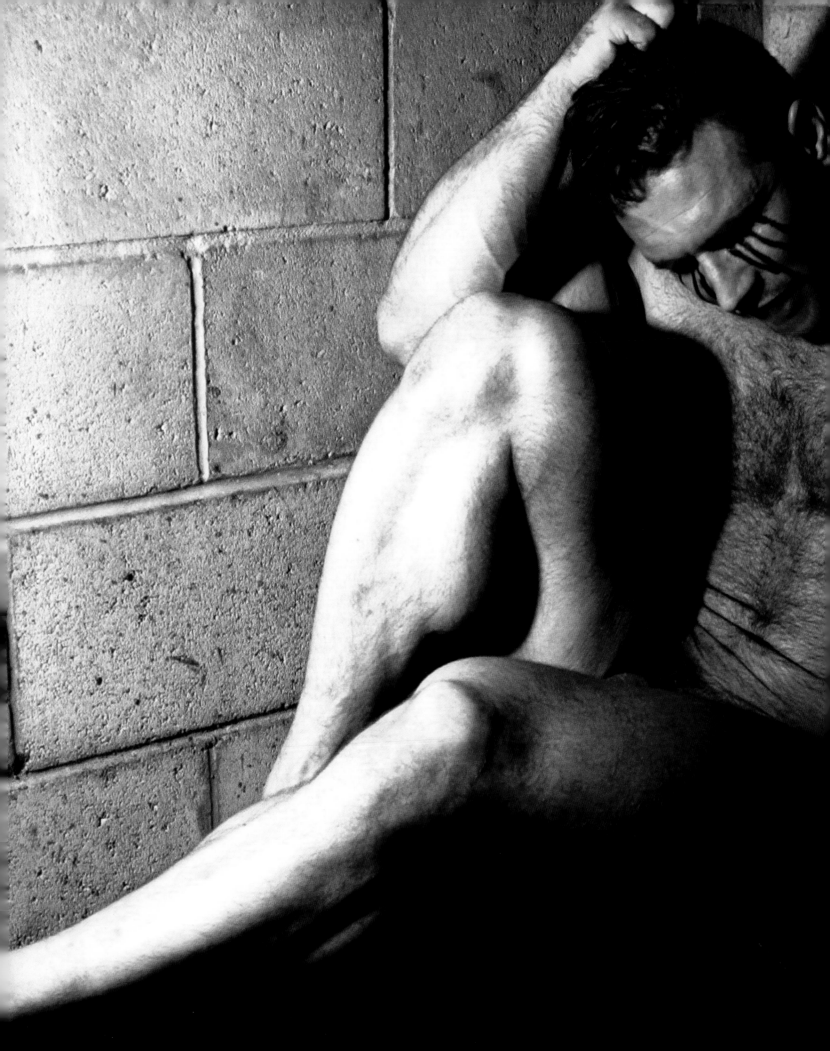

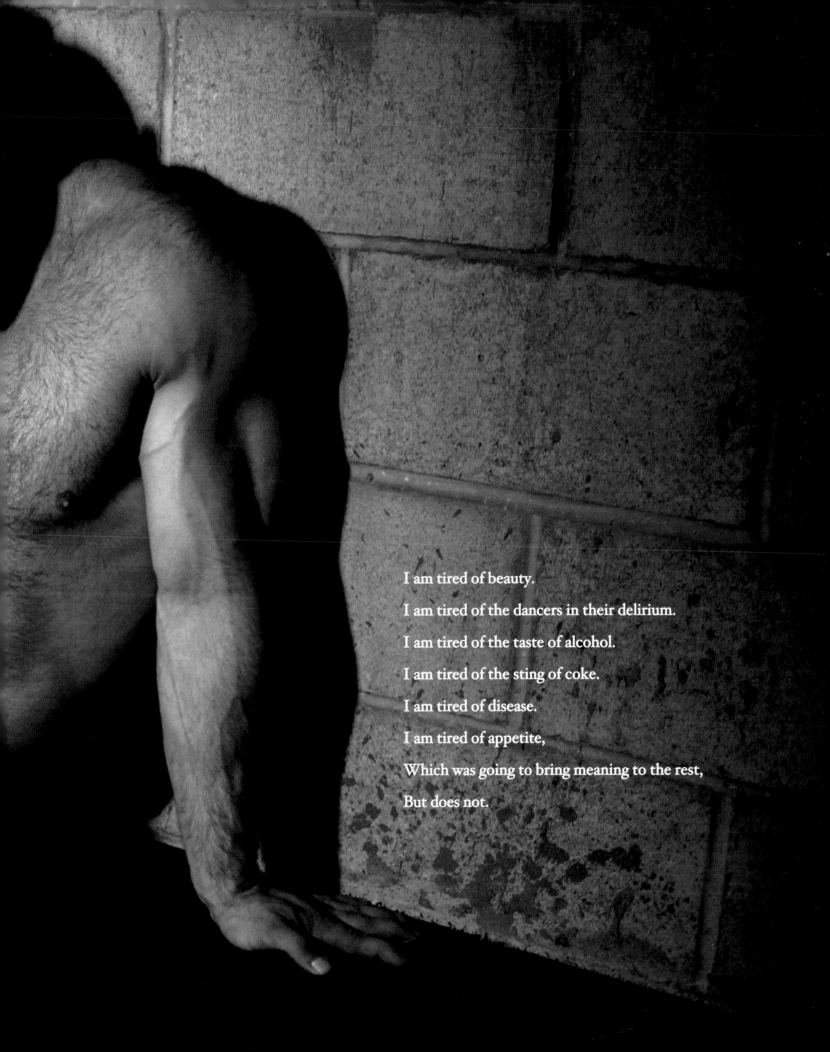

I am tired of beauty.

I am tired of the dancers in their delirium.

I am tired of the taste of alcohol.

I am tired of the sting of coke.

I am tired of disease.

I am tired of appetite,

Which was going to bring meaning to the rest,

But does not.

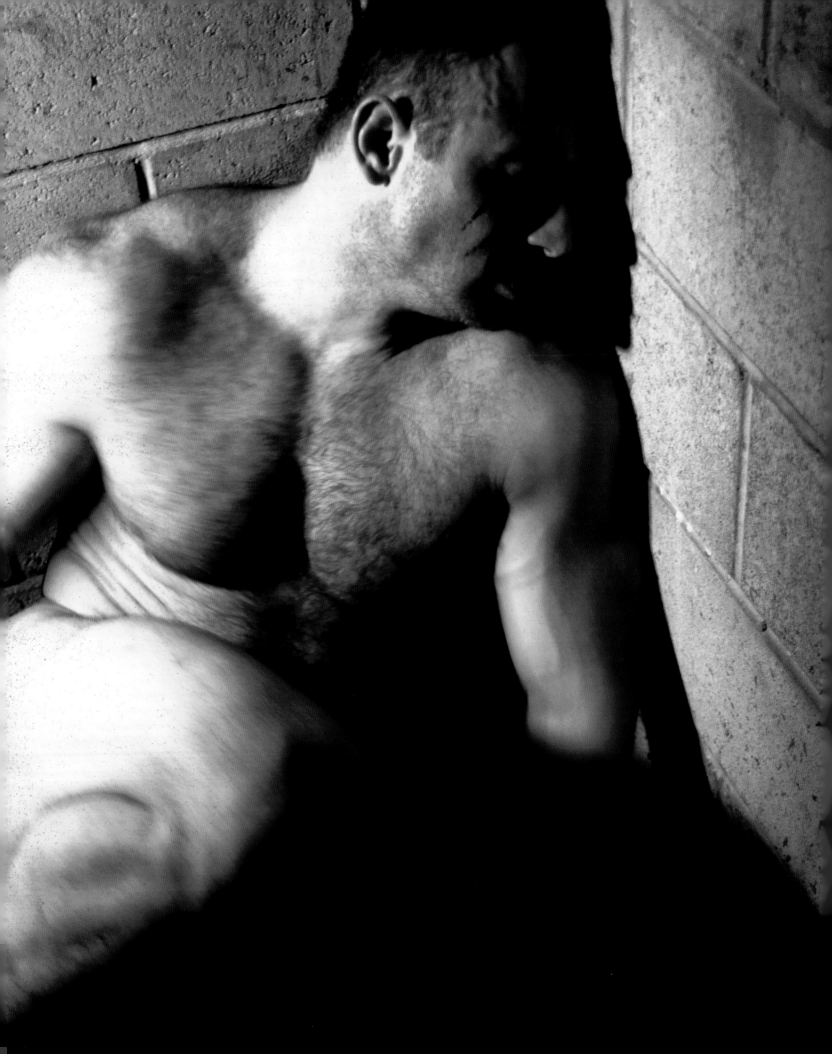

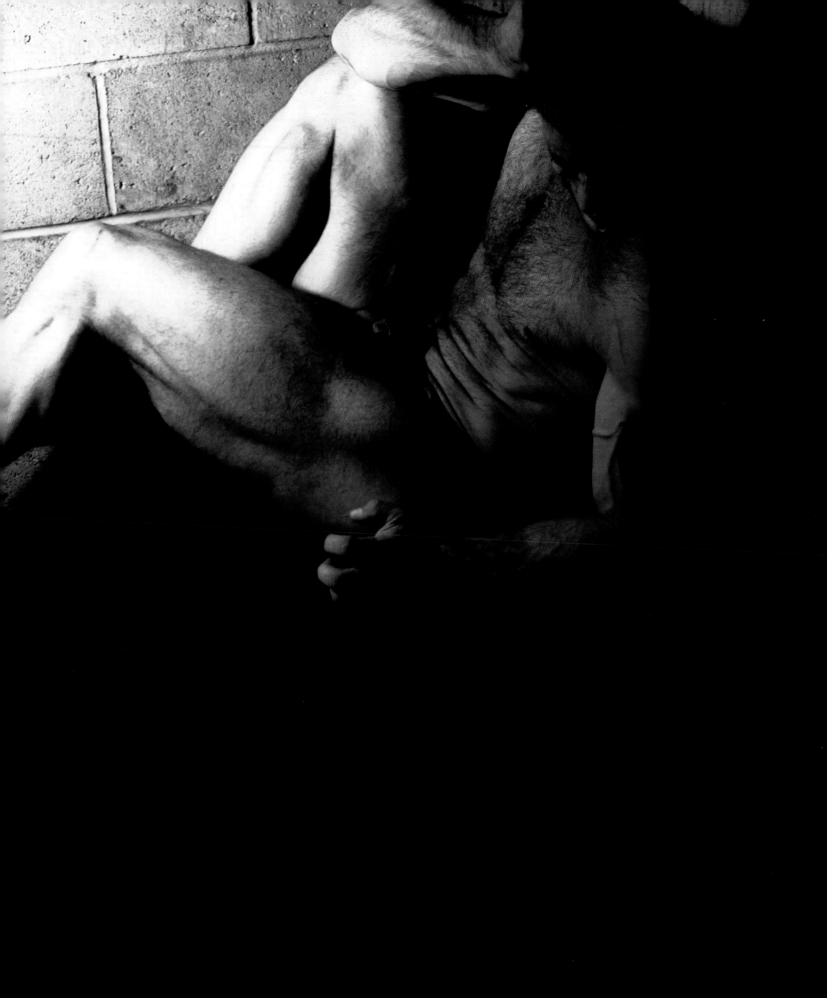

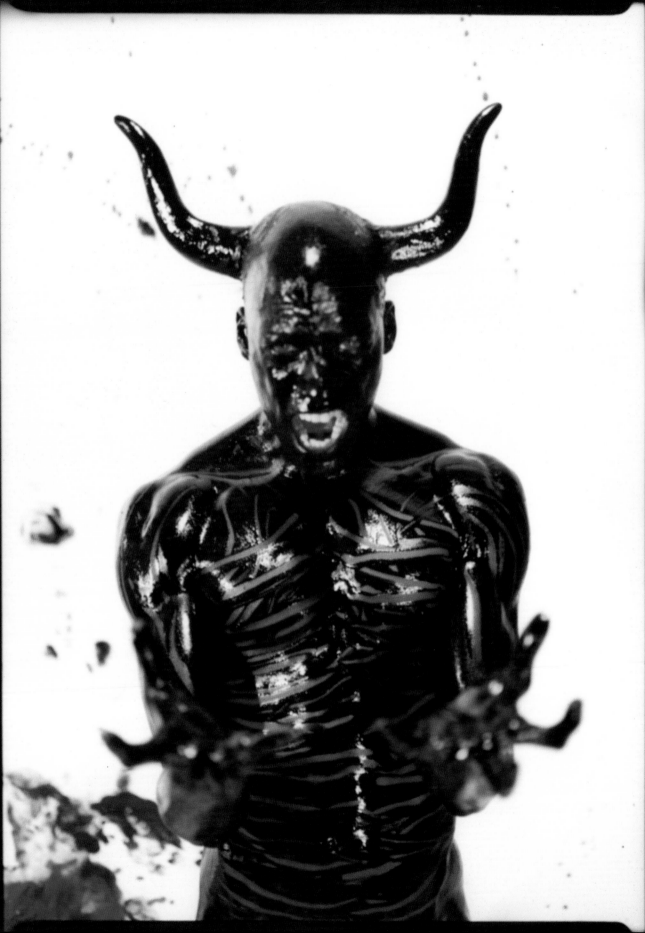

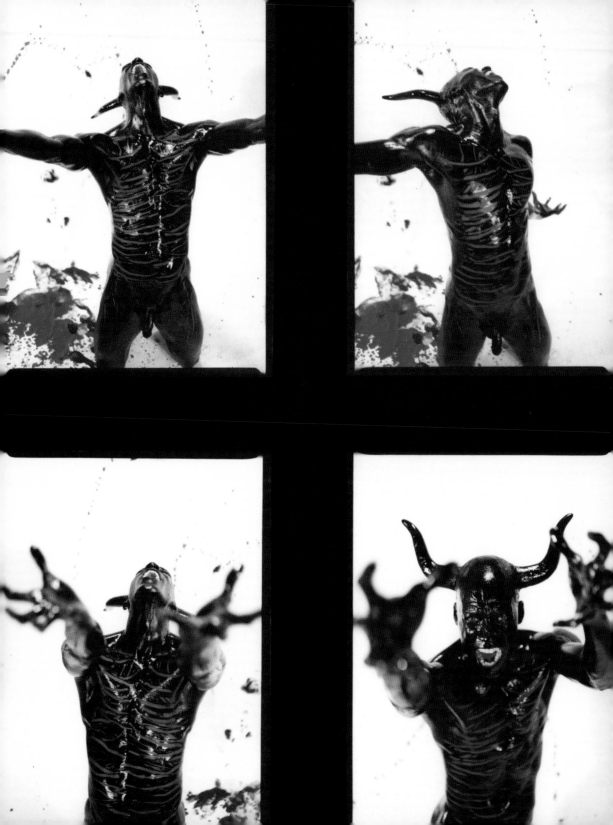

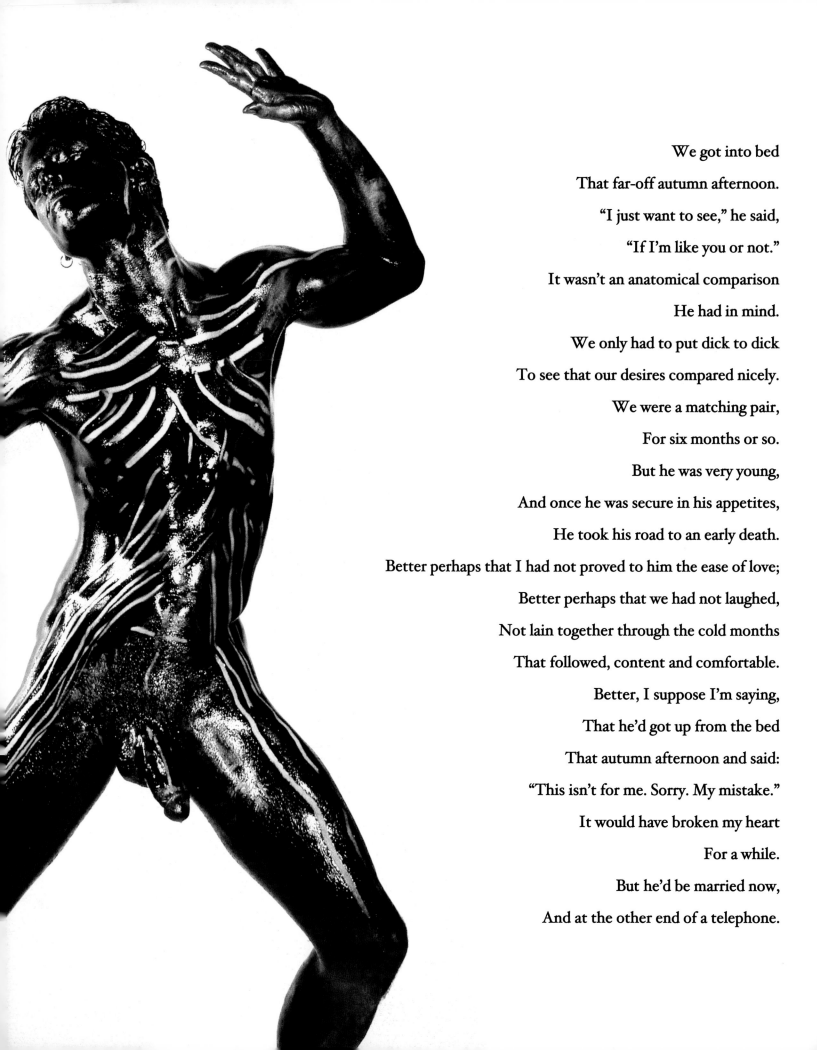

We got into bed

That far-off autumn afternoon.

"I just want to see," he said,

"If I'm like you or not."

It wasn't an anatomical comparison

He had in mind.

We only had to put dick to dick

To see that our desires compared nicely.

We were a matching pair,

For six months or so.

But he was very young,

And once he was secure in his appetites,

He took his road to an early death.

Better perhaps that I had not proved to him the ease of love;

Better perhaps that we had not laughed,

Not lain together through the cold months

That followed, content and comfortable.

Better, I suppose I'm saying,

That he'd got up from the bed

That autumn afternoon and said:

"This isn't for me. Sorry. My mistake."

It would have broken my heart

For a while.

But he'd be married now,

And at the other end of a telephone.

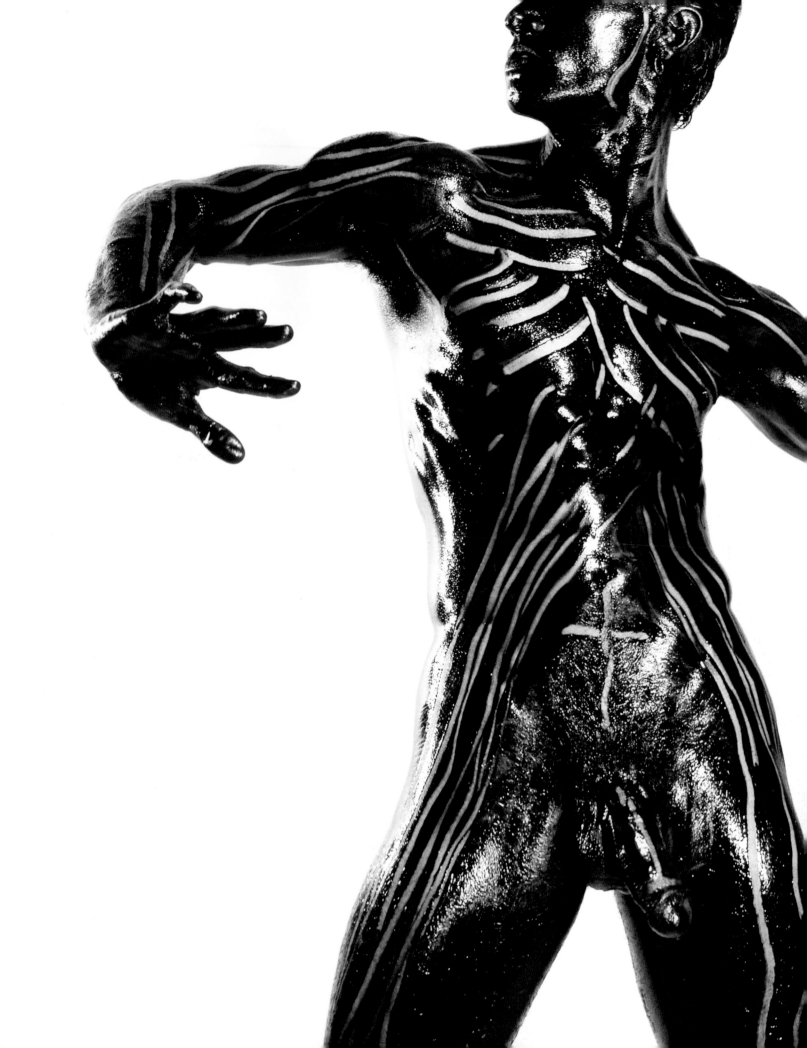

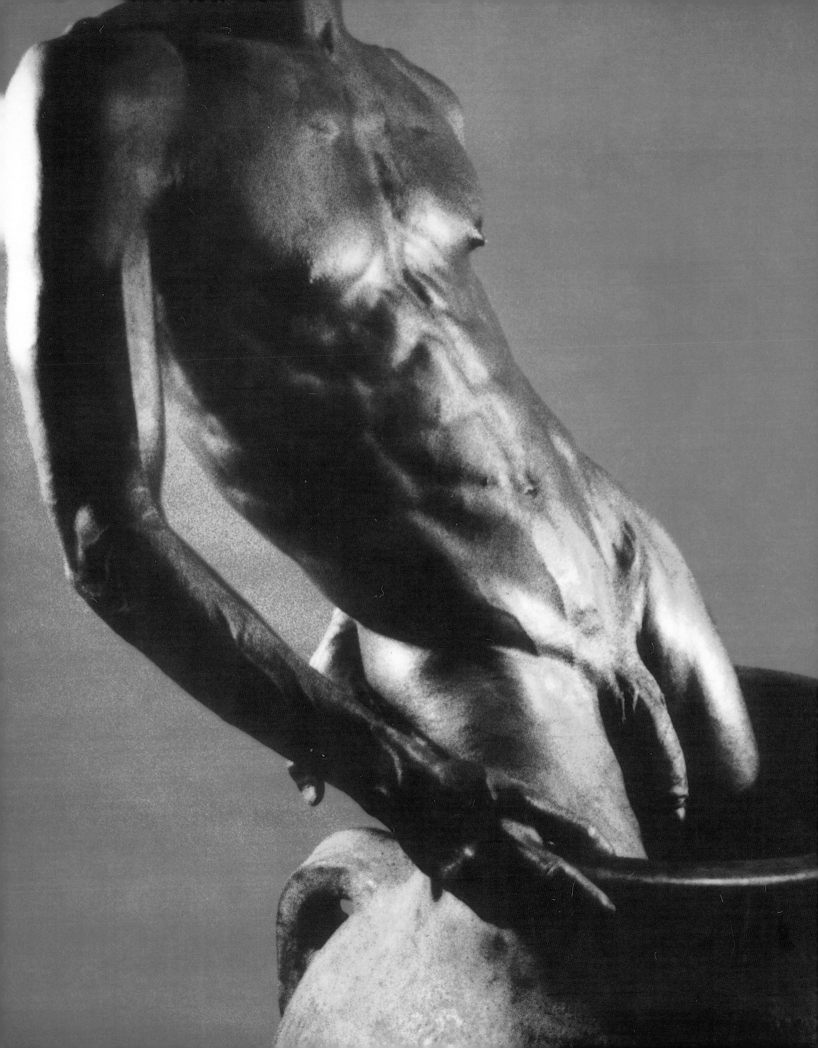

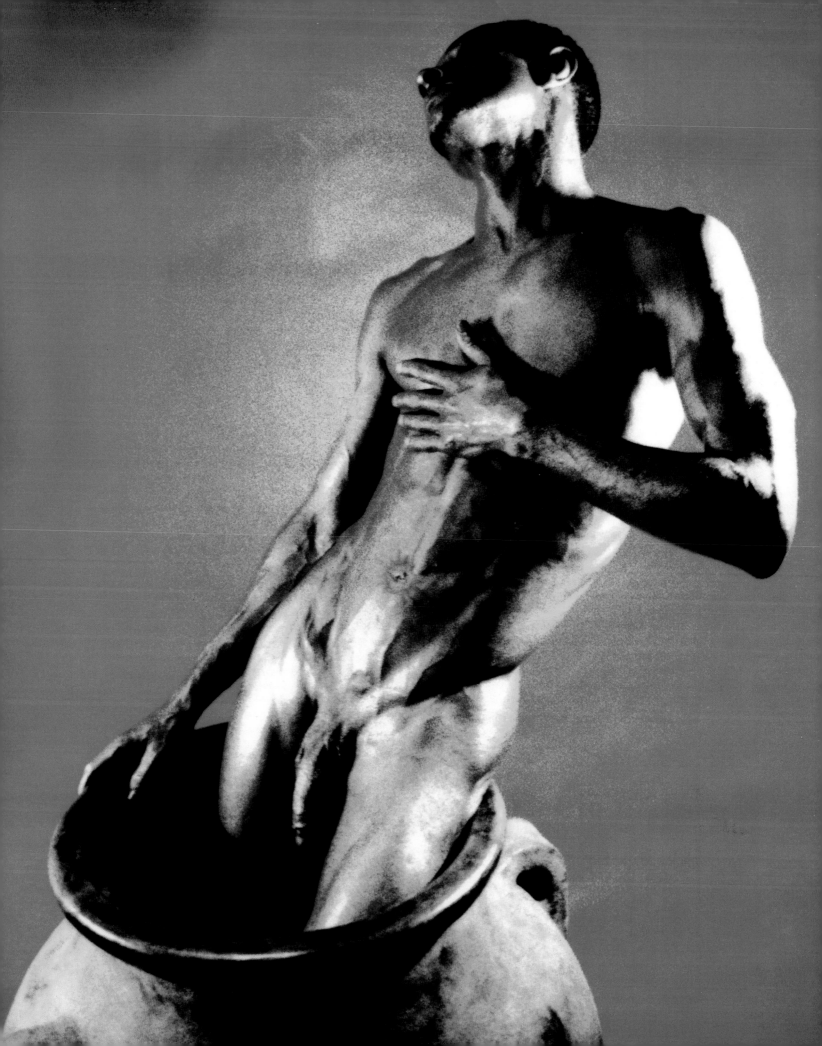

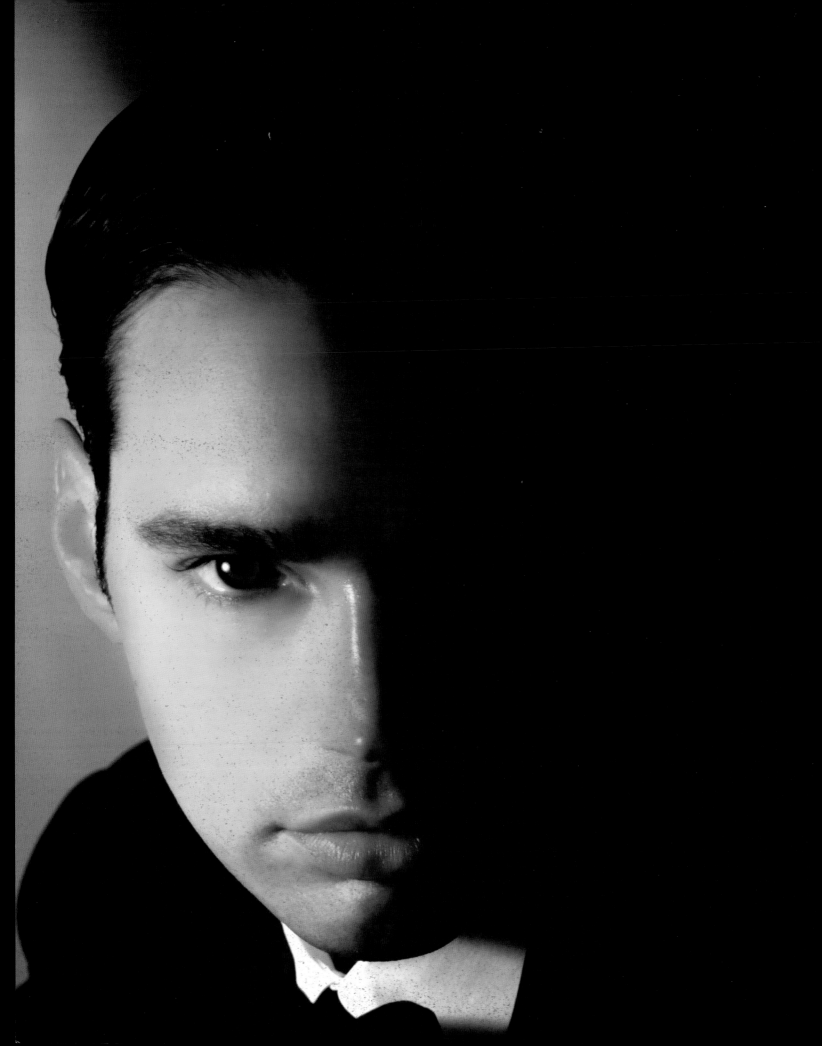

Youth inhabits his face

Like a hermit crab its borrowed shell.

He will outgrow his shelter sooner than he thinks.

Only then will he know what it is to be naked.

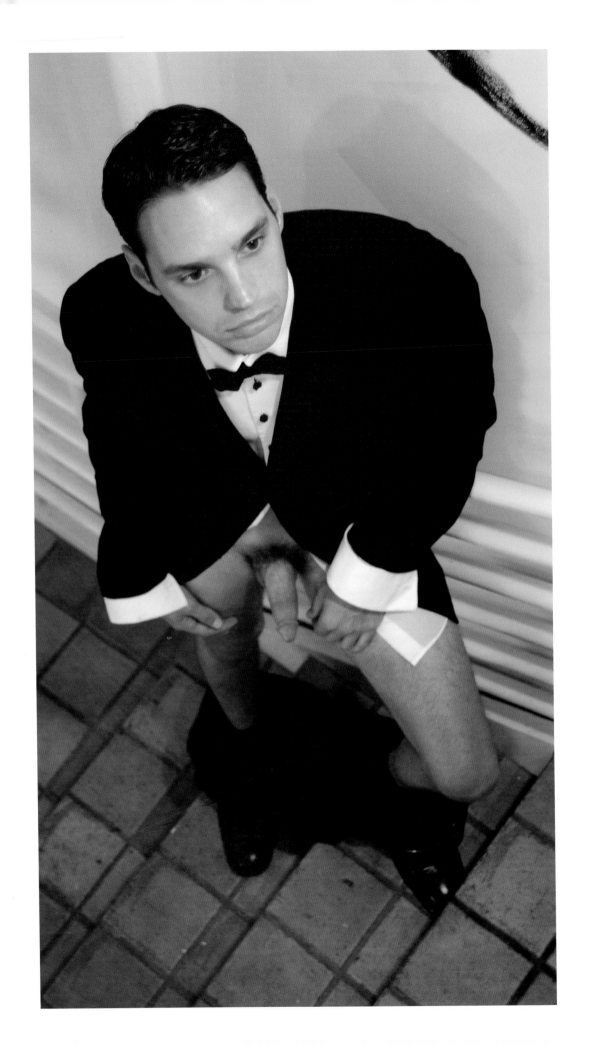

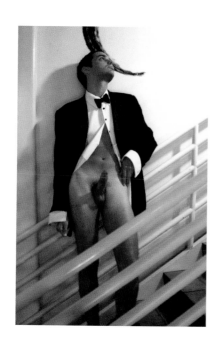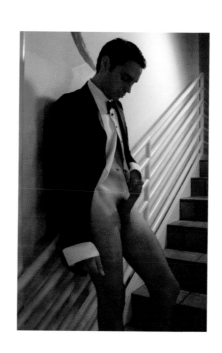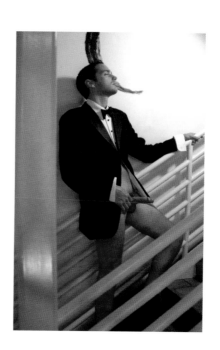

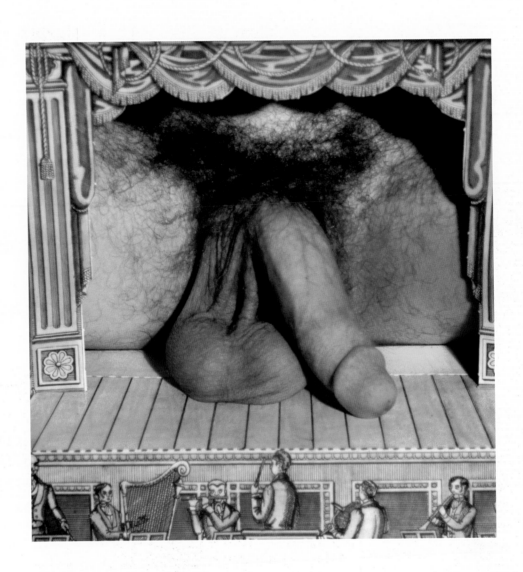

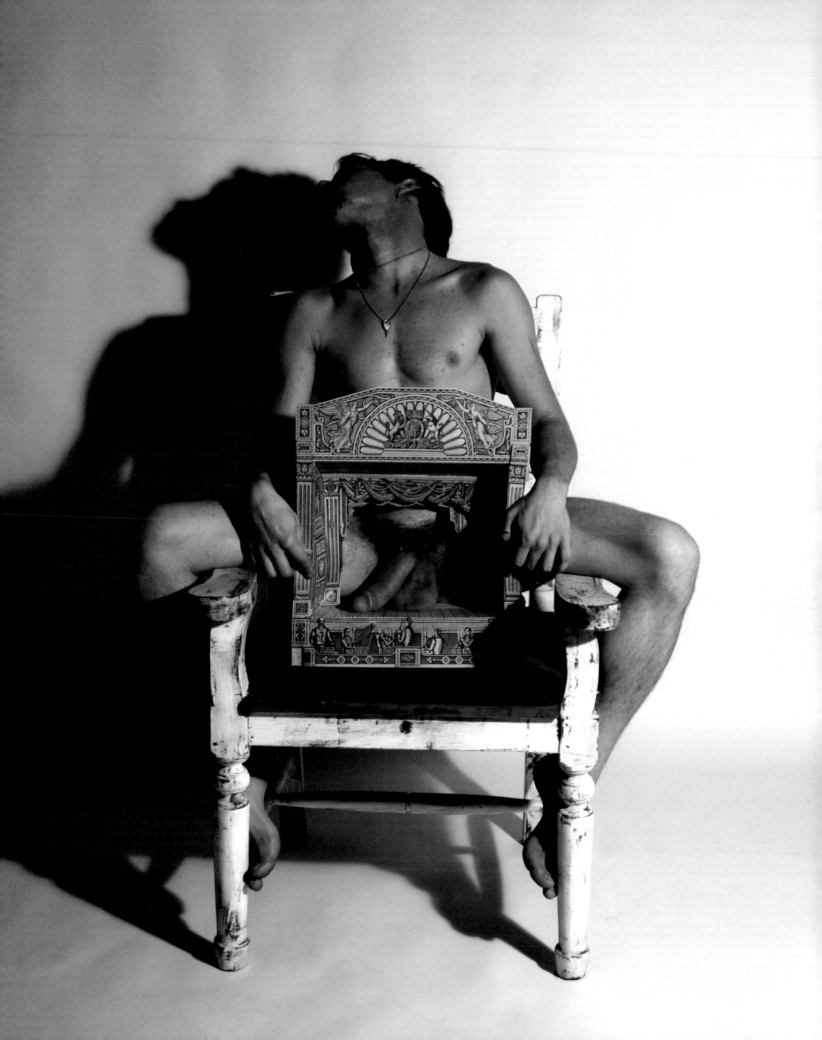

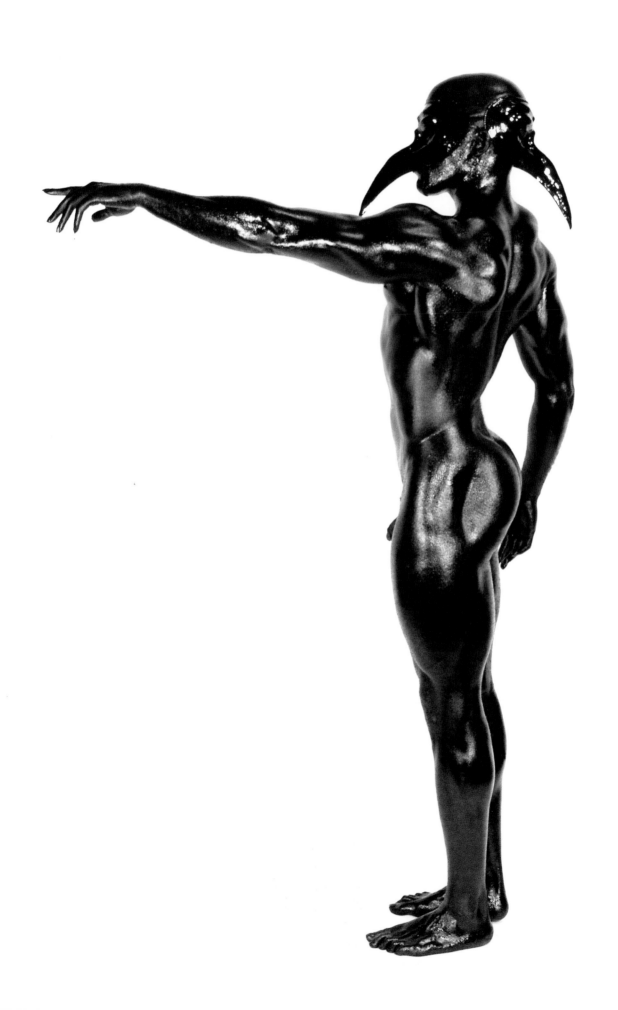

Bird you fly so fast

You do not see the seed

I threw down for you.

How will you bring news

Of my kindness to heaven

If you do not stop to taste it?

Lord, I fly so fast

I do not see the bliss

You threw down for me.

How will I bring news

Of your kindness to my heart,

If I do not stop to taste it?

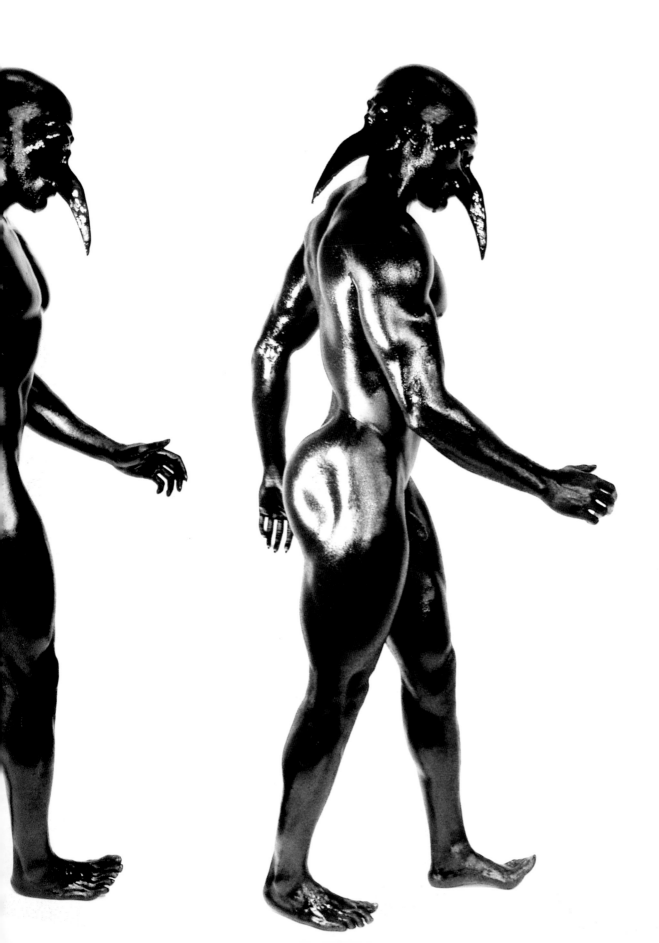

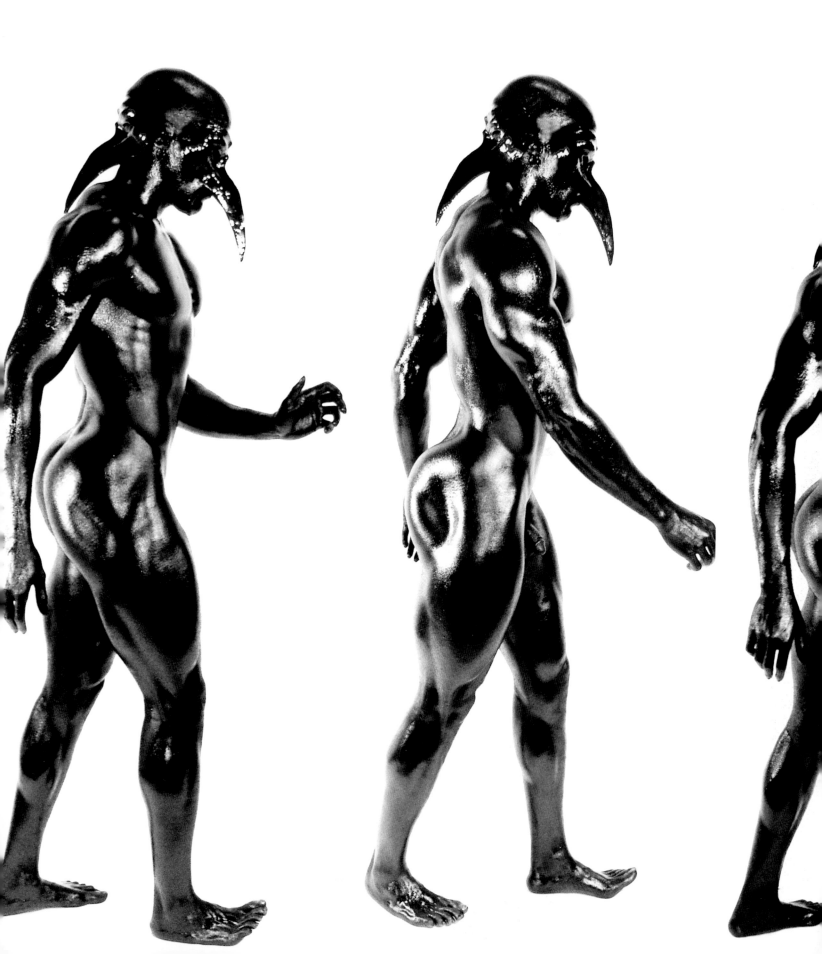

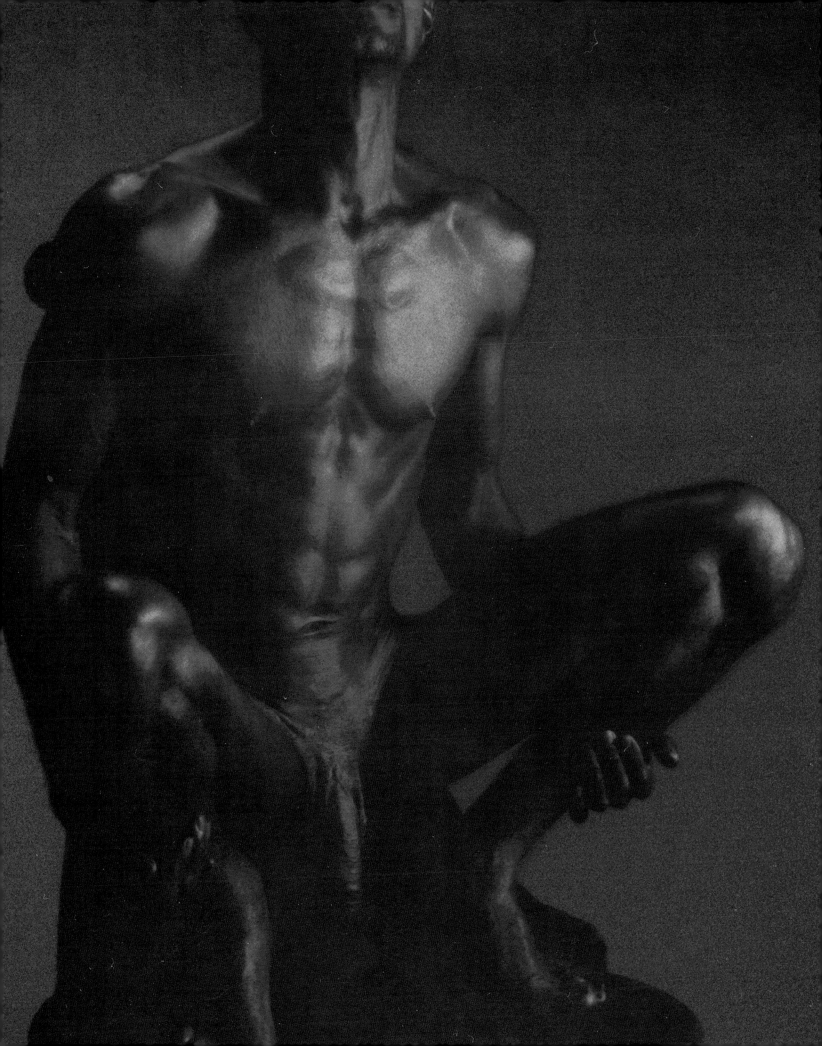

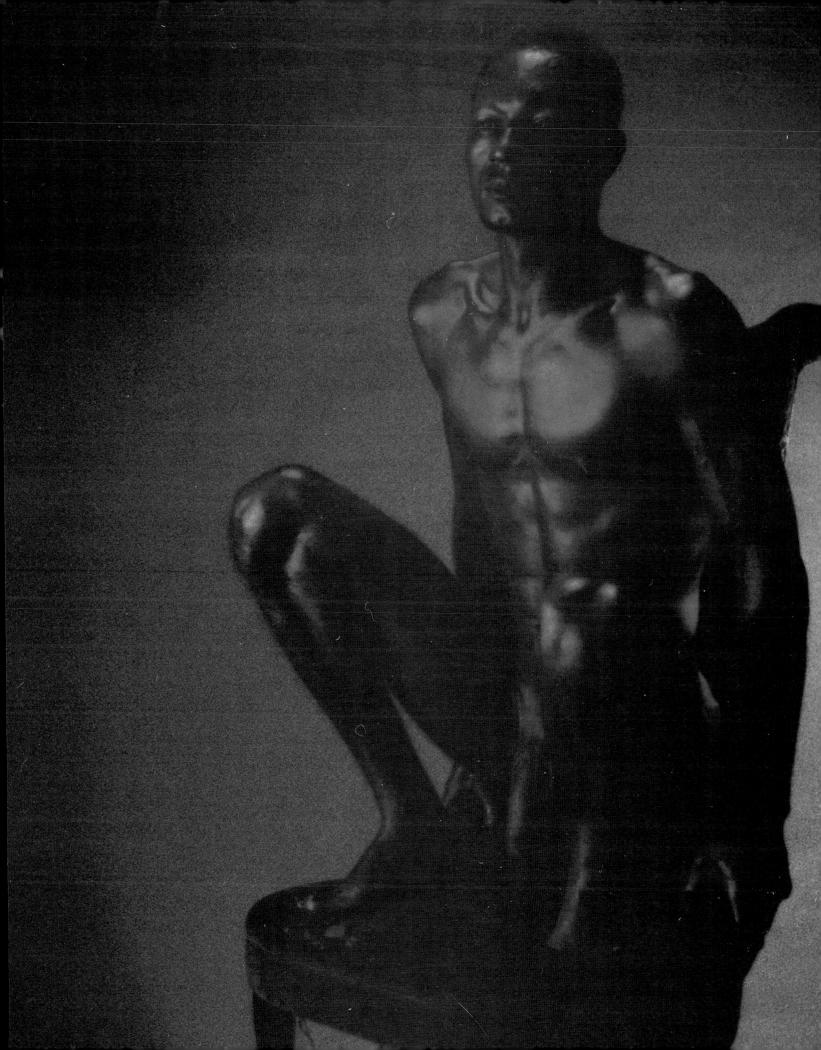

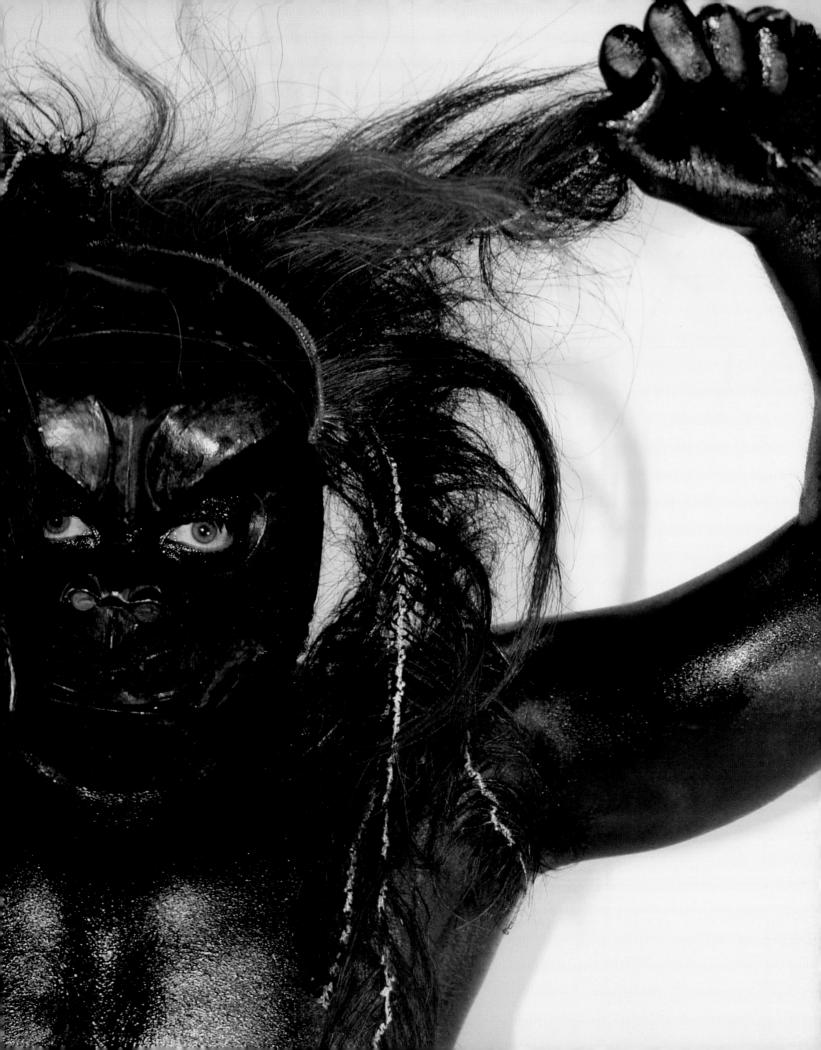

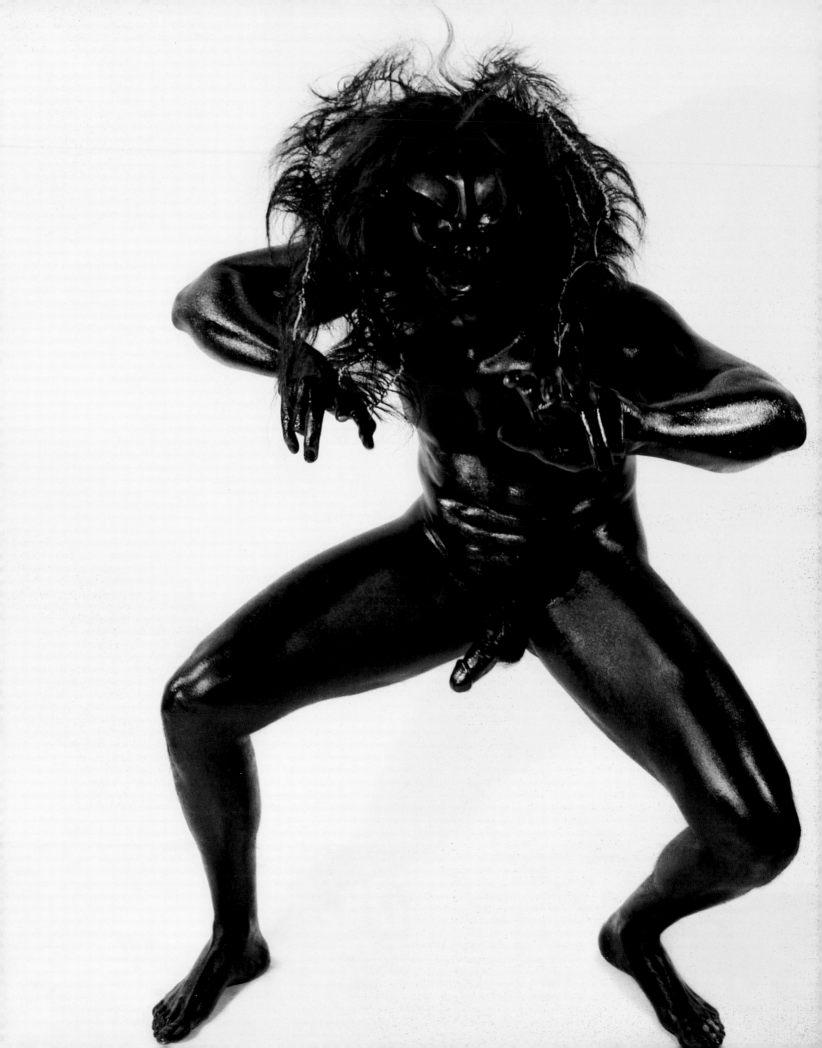

Burn me! Hurt me!

Dick and dirt me!

Bite me! Dyke me!

Hammer and spike me!

Rut me! Slut me!

Coo and cut me!

Root me, ride me!

Fire inside me!

Wrap me tight,

And hide me,

Hide me!

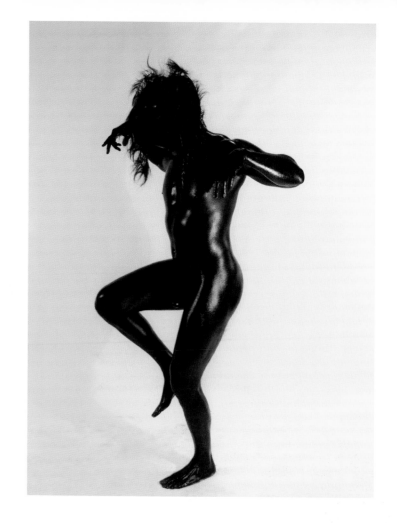

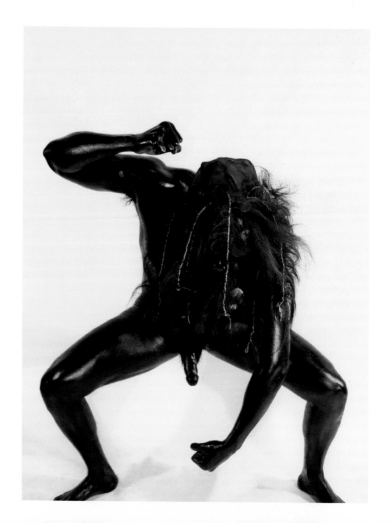

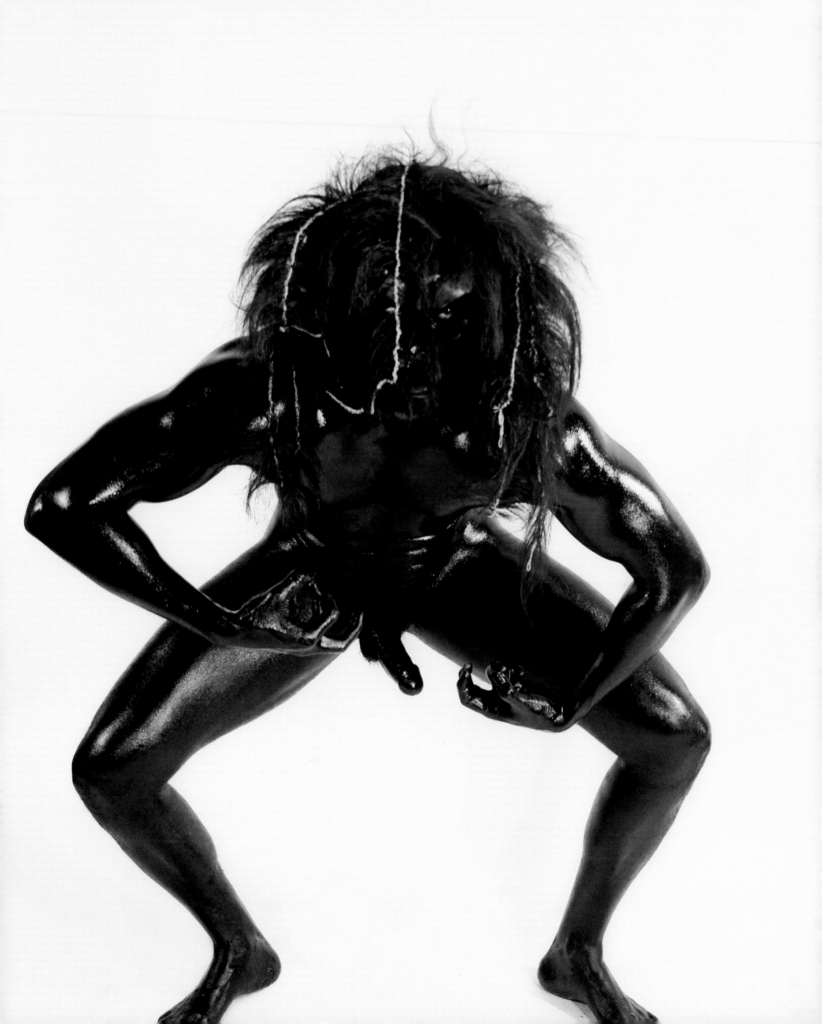

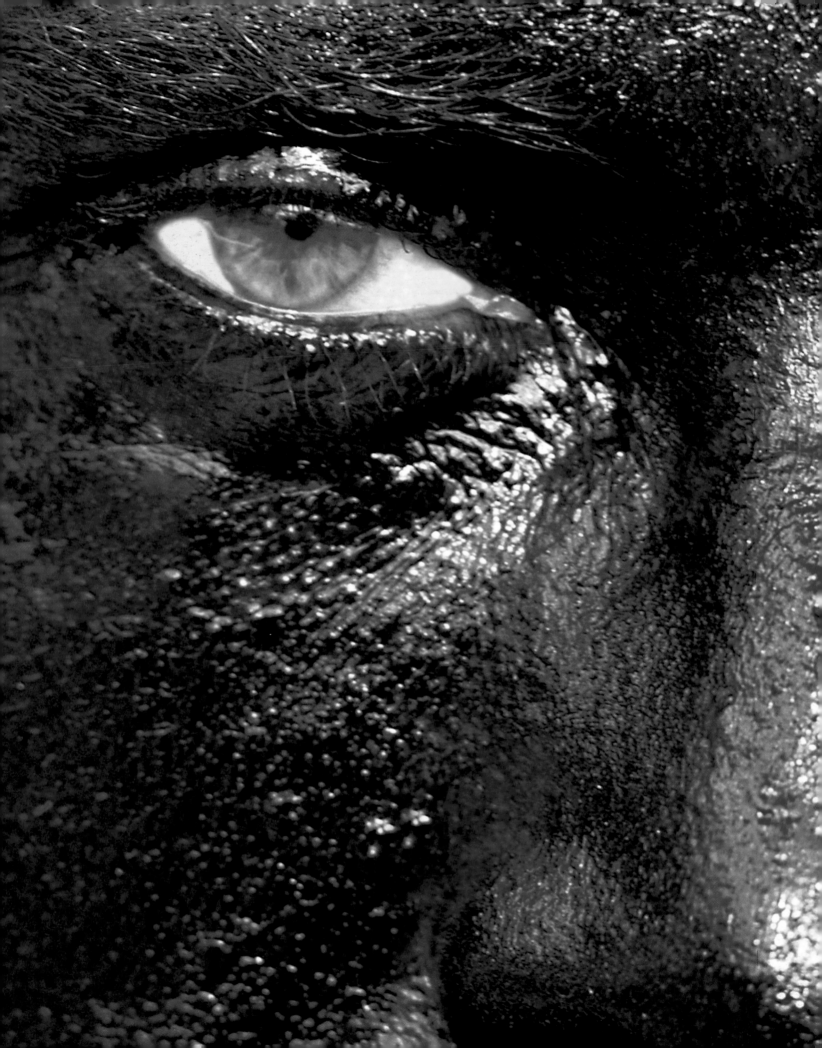

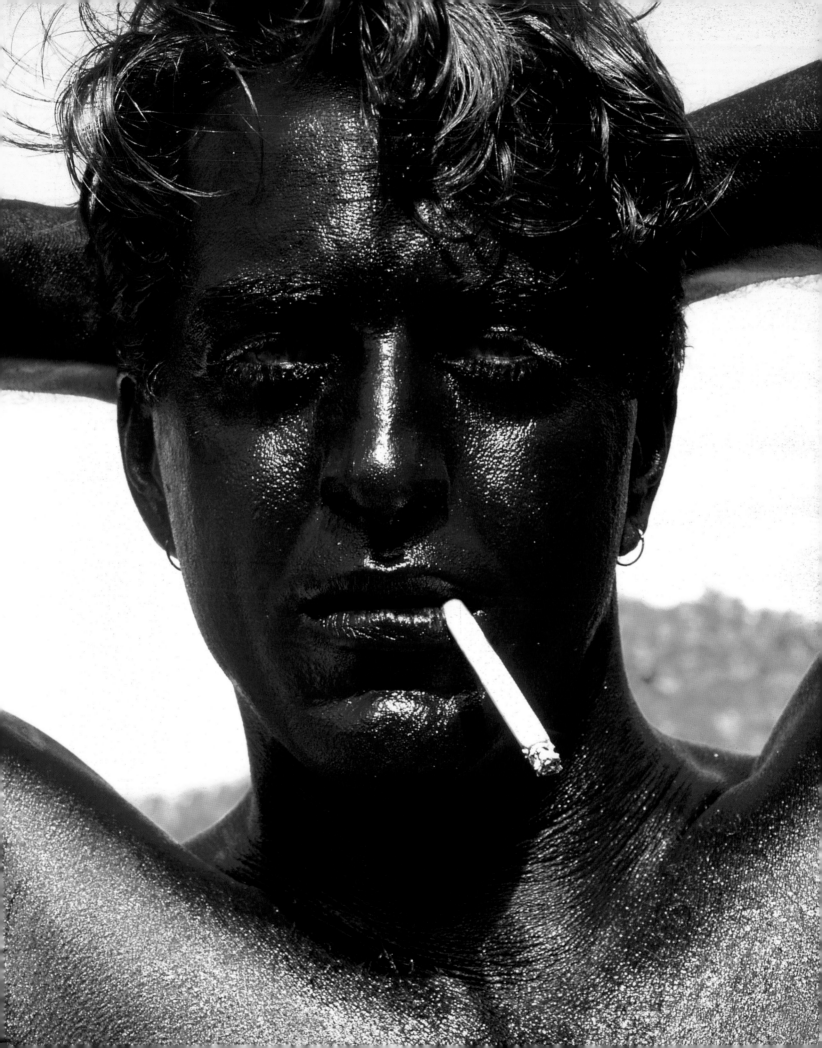

I dream of broken hearts tonight,

And one of them is mine.

It will not mend with sympathy,

It won't be healed by wine.

The only balm I can conceive

To put the hurt to right,

Would be, my sweet, if you

Were not to live beyond tonight.

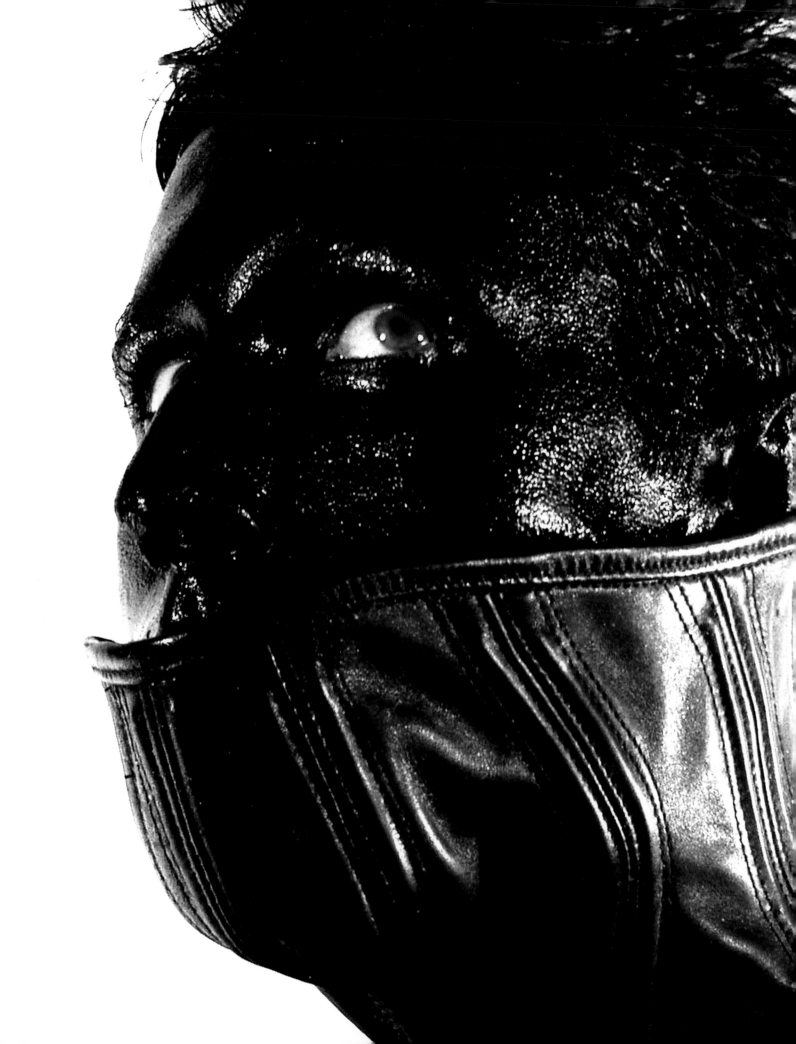

The Scarlet Gospels

Rael's
Confession

So that I might feed my gospels to it, my Scarlet Gospels. It's all I can do not to go to my folios—which are filled to bursting with the fruits of almost two thousand years' of patient curating—and snatch the booty up, and burn it.

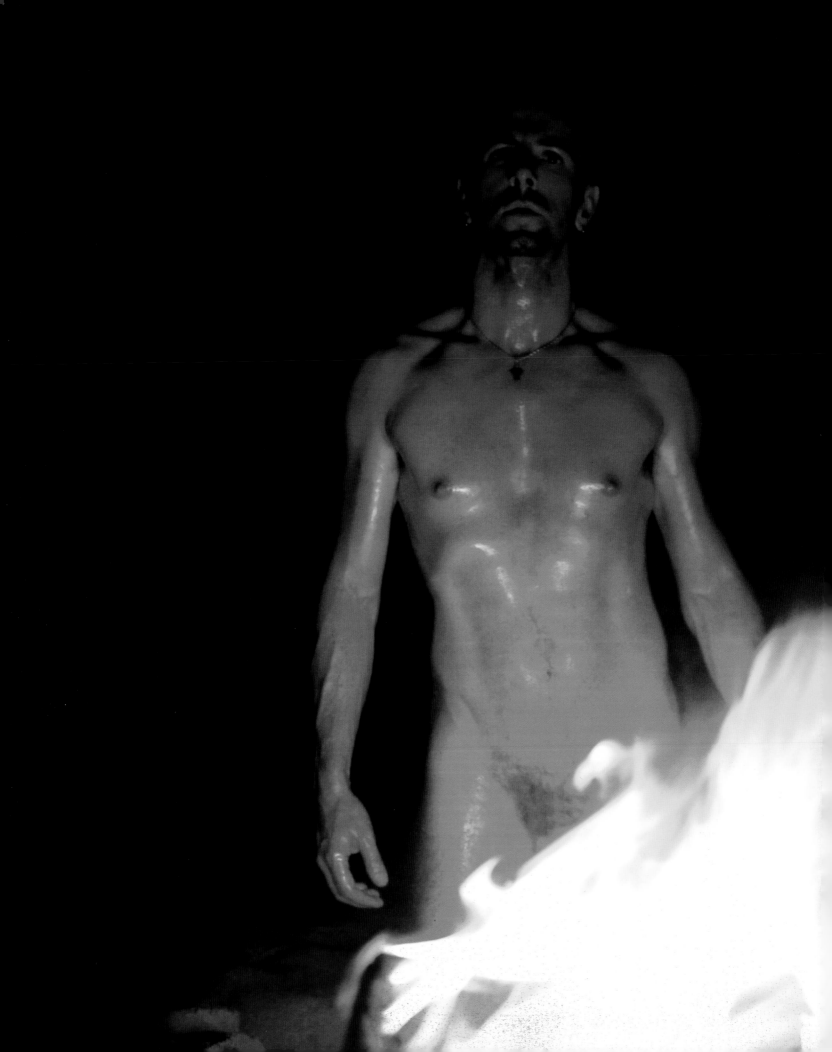

Every lurid, filthy, corrupted, sweaty, sickening word. Every sketch, every photograph, every last thing that speaks of human desire. More than once I've stopped myself in the very act of picking my treasures up, my fingers pregnant with fire, the papers in my hand. I've lost several pieces because I didn't change my mind quickly enough. Up they went, before I could stop them. They weren't heart-breaking losses. A few dirty pictures, a few filthy rhymes. So what if they were the expression of some lustful soul who had passed into oblivion? Lust and souls were never in short supply. One less obscenity to begrime the world. Where's the tragedy in that? But tomorrow, I will probably have a different opinion. Tomorrow, the dark mood will perhaps have passed, and my mind may be clearer. Then I'll be glad I didn't give way to my revulsion.

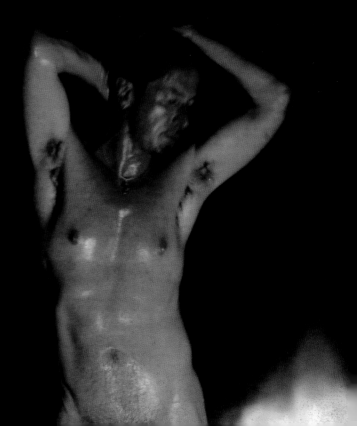

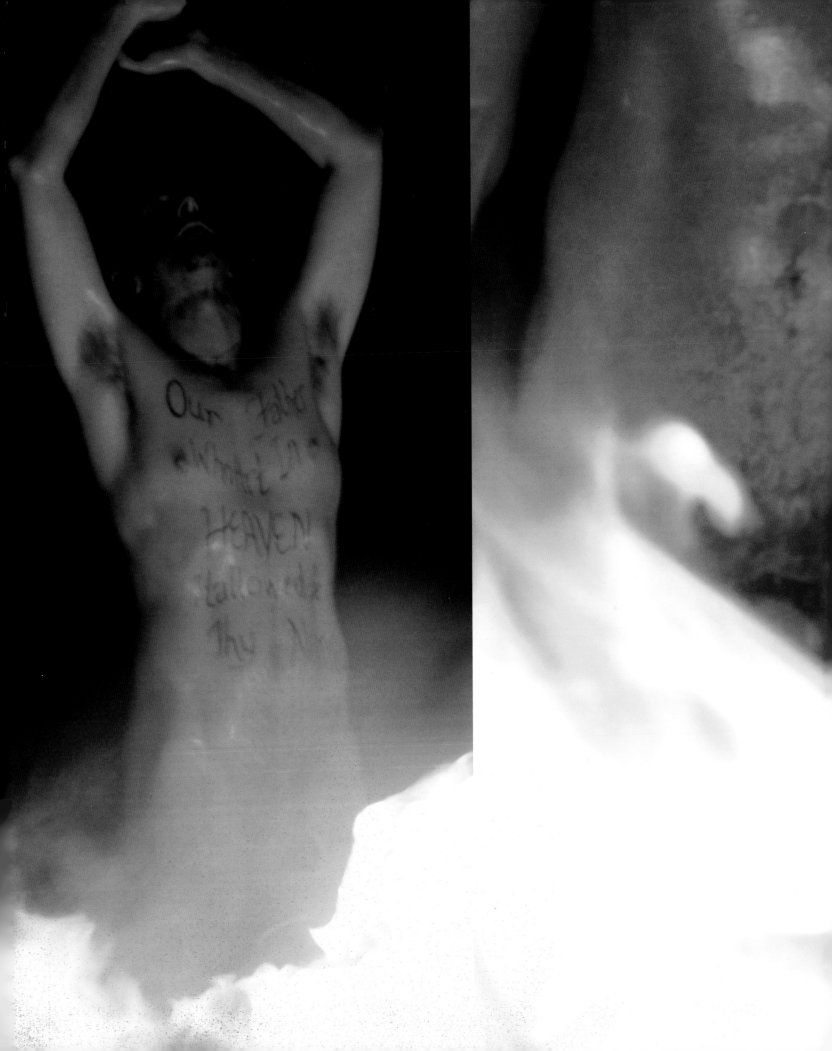

And so it proves. I am writing this a day later, and the worst of my despair

has cleared. I have decided, in the light of a more hopeful mood, to begin

the business of organizing my collection. I've put it off for the better part

of two millennia. You may assume it presents a considerable challenge.

But I have to begin somewhere.

Here then, for the record, are the essential facts.

My name is Rael, I am an angel.

And these are my scarlet gospels.

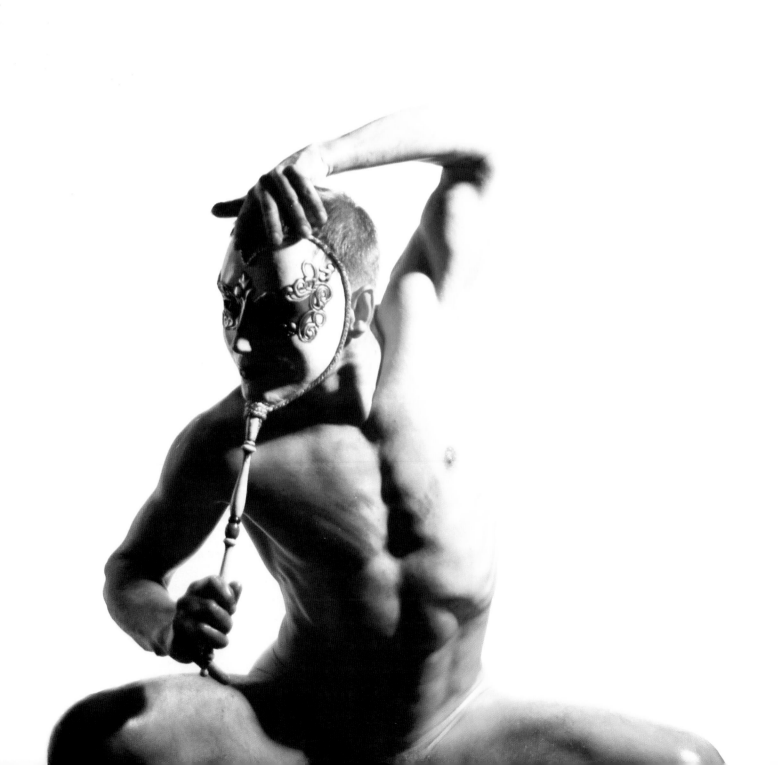

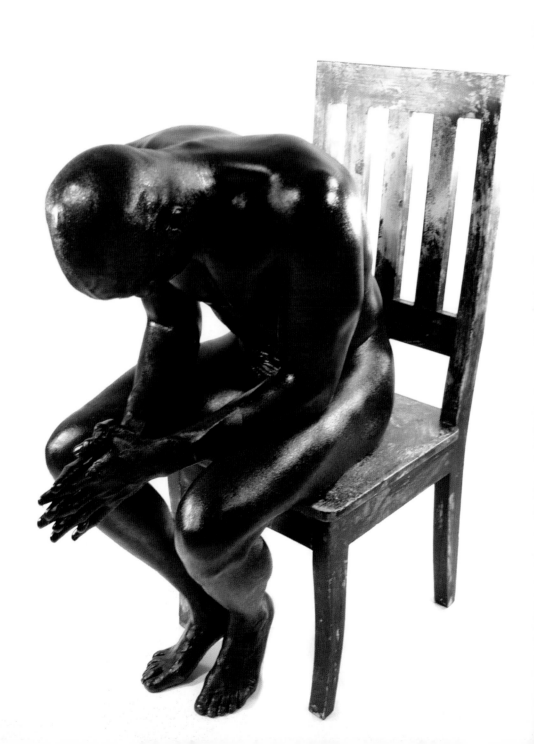

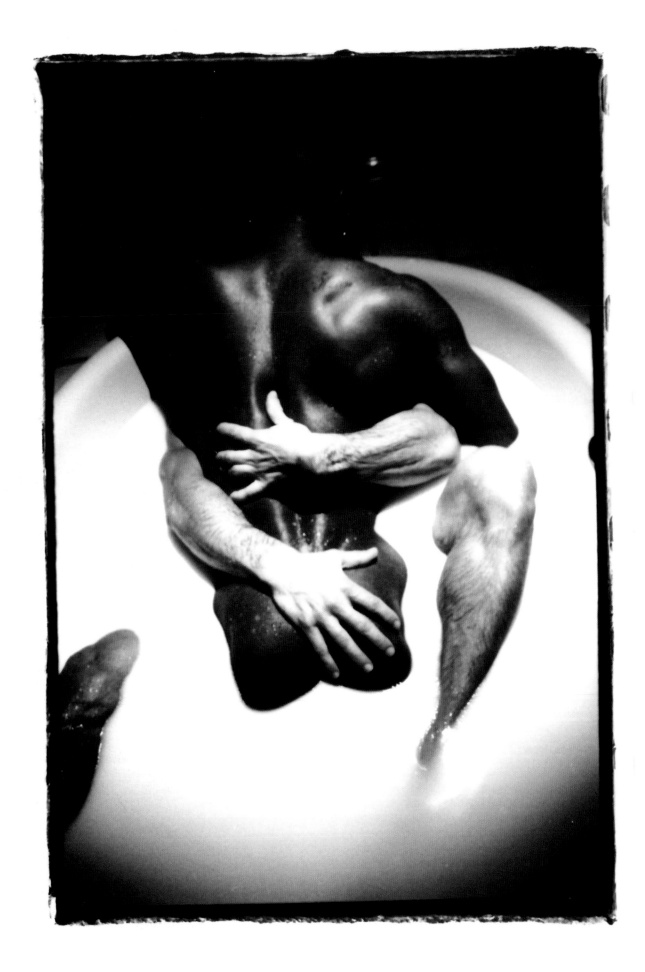

I

I will be a lobster,

Crusty in my chair,

And young admirers will come to

Hold my tender pincers

In their hands,

And say how much they were moved,

In their youth,

By this that I did, or that.

And my eyes will water

From the effort of keeping them open.

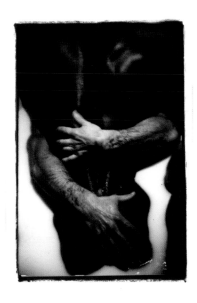

II

Or I will be a memory,

Dusty in my casket,

Having slipped to sleep too early

For my ambitions to be realized.

And when I am recalled in conversation

They will say: "What a pity!

He might have made a thing or two

Worth keeping, had he survived."

And their eyes will water

From the effort of trying to picture me.

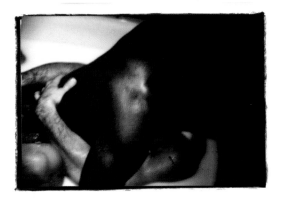

III

But whichever it is—

I will be with you.

And neither death nor reputation will matter.

The shell in the chair will be empty,

The casket empty too.

We will be off,

Into some mightier place,

Hand upon hand.

The light of the moon my voice,

The sun your face.

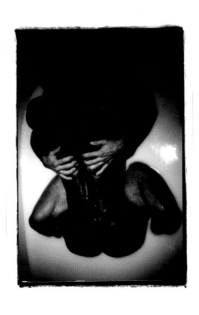

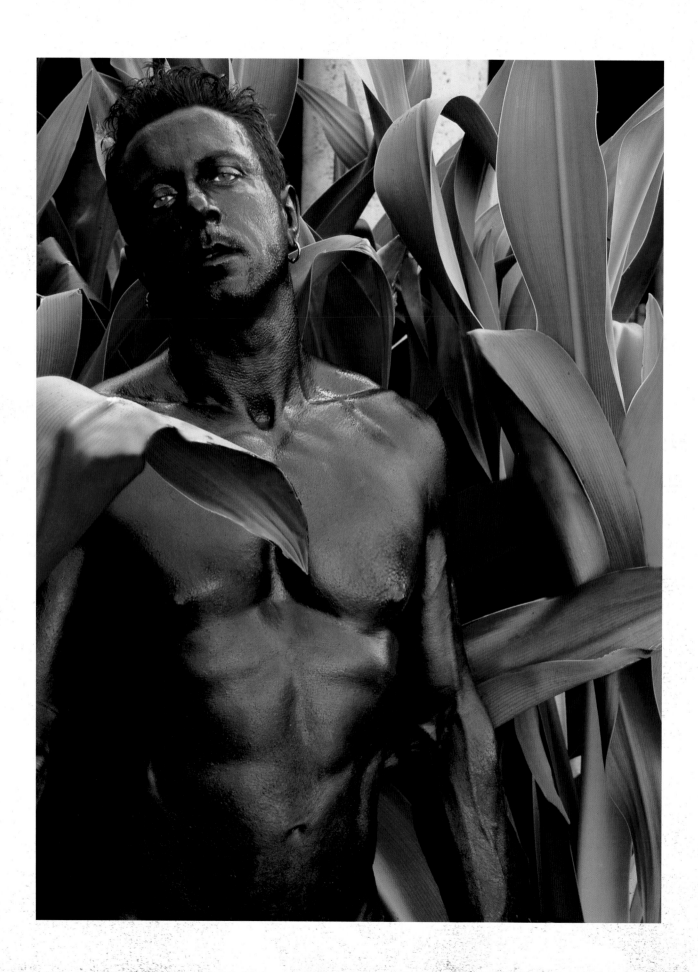

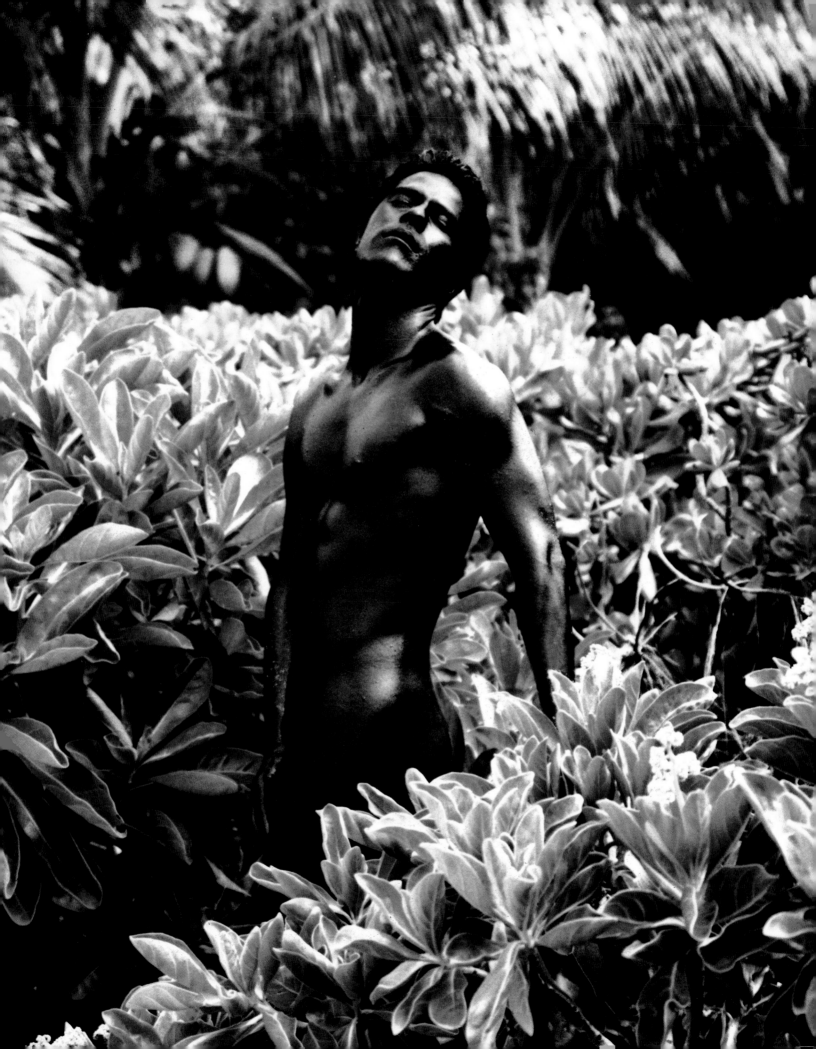

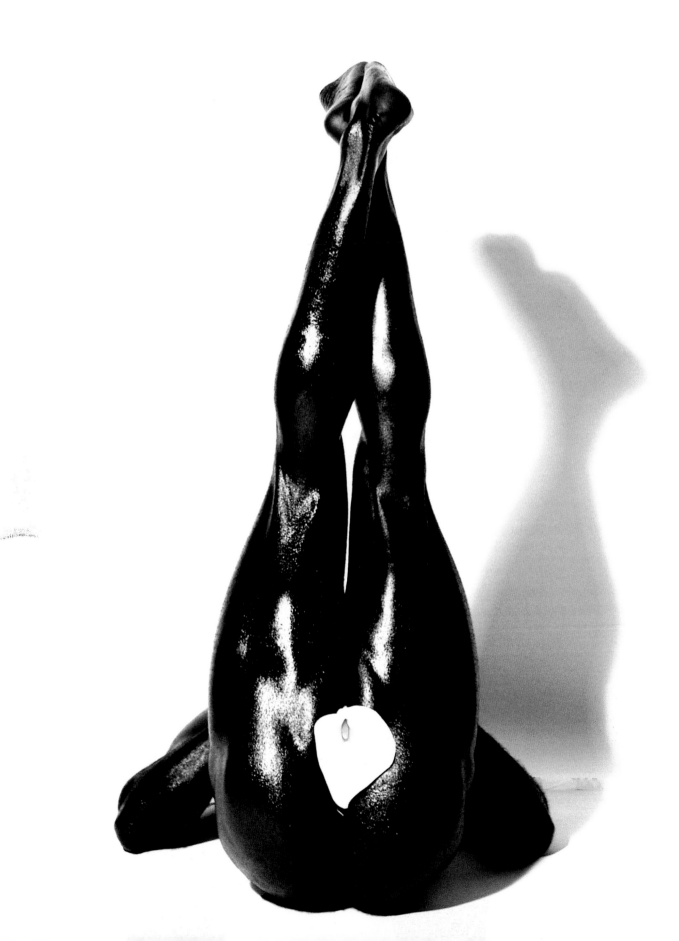

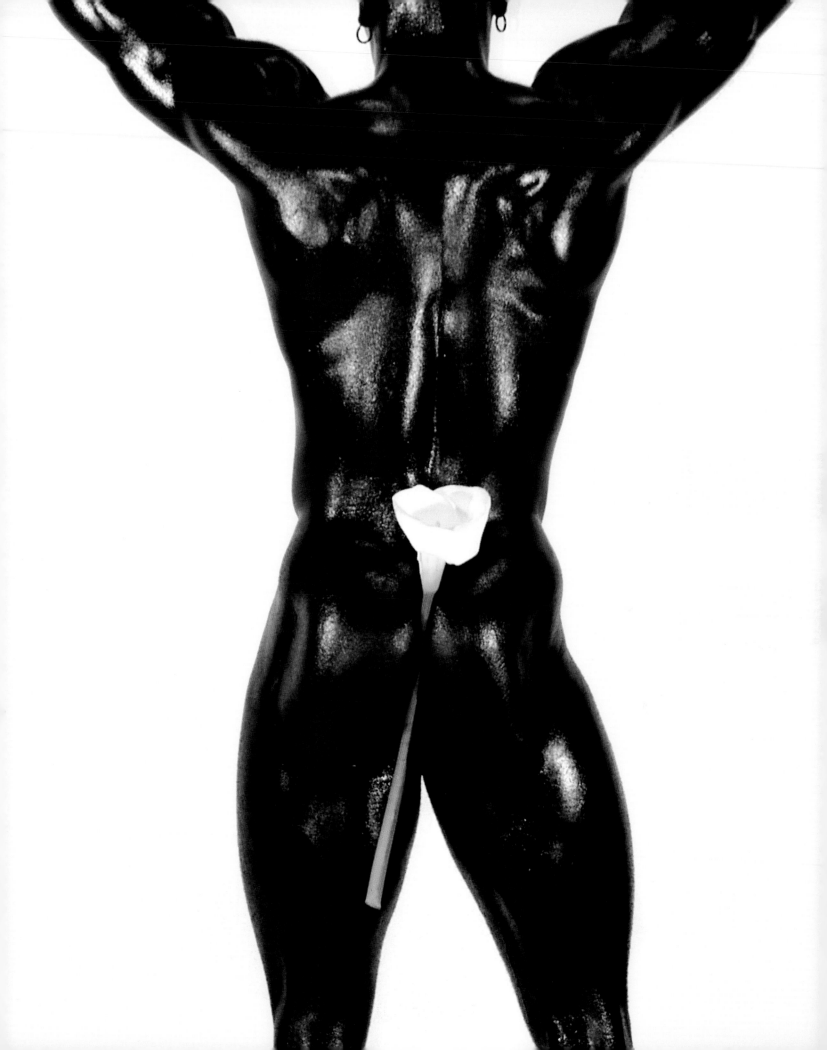

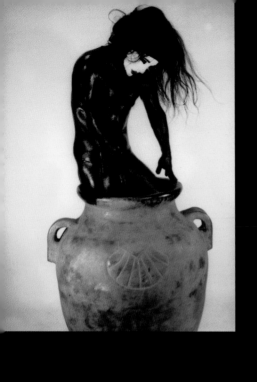
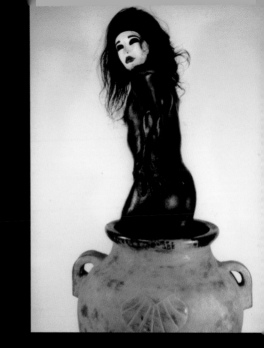
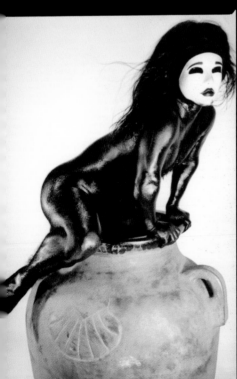
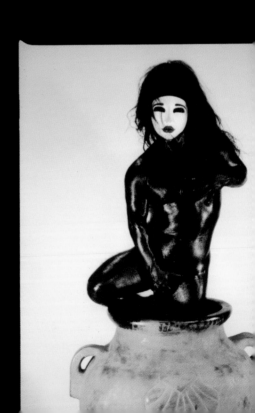

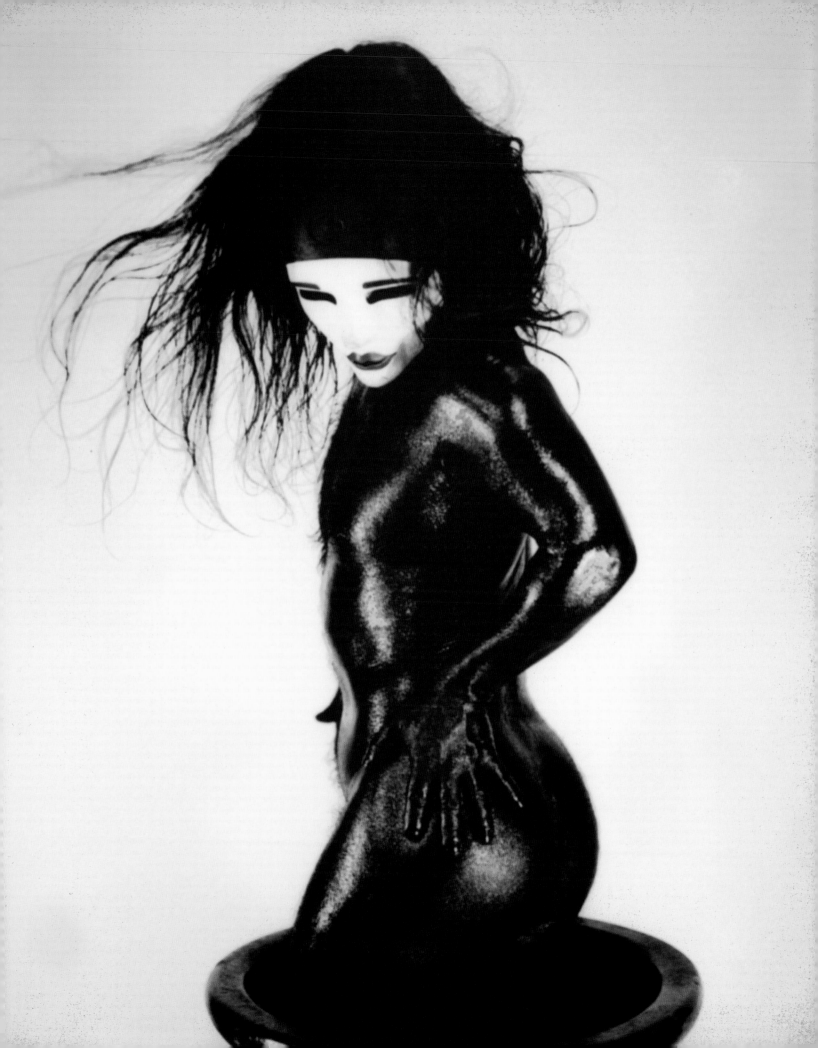

Love is love

is Love

is

Love

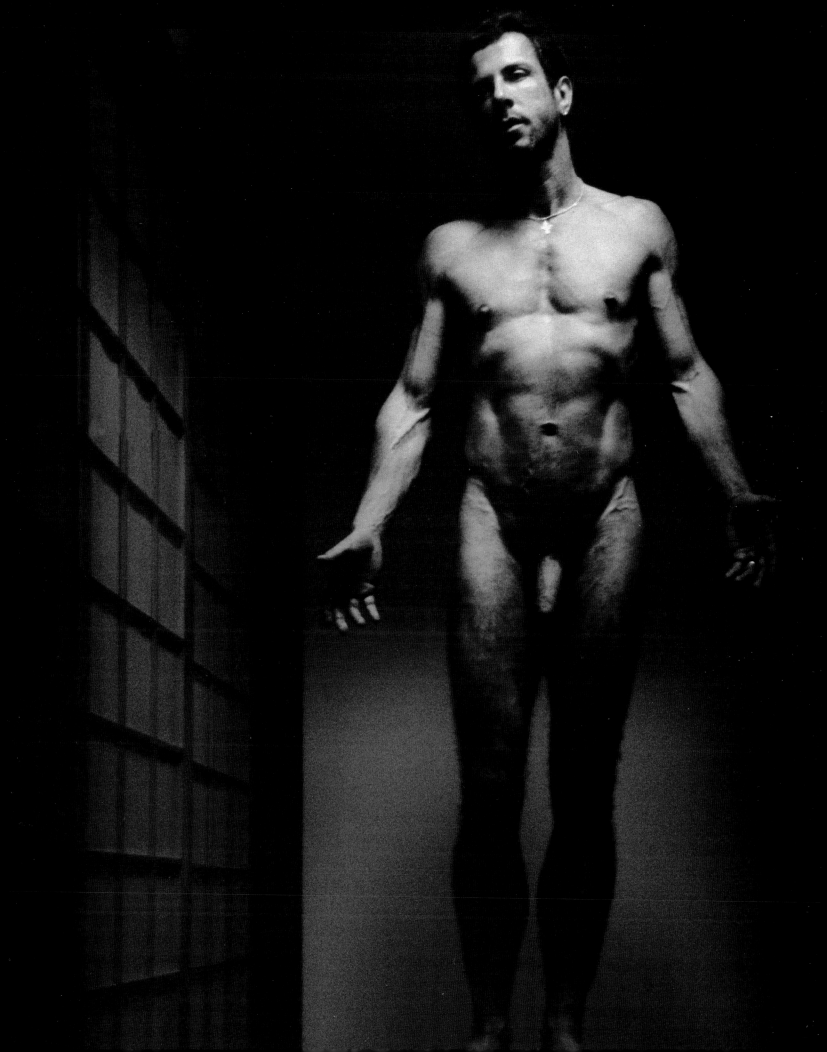

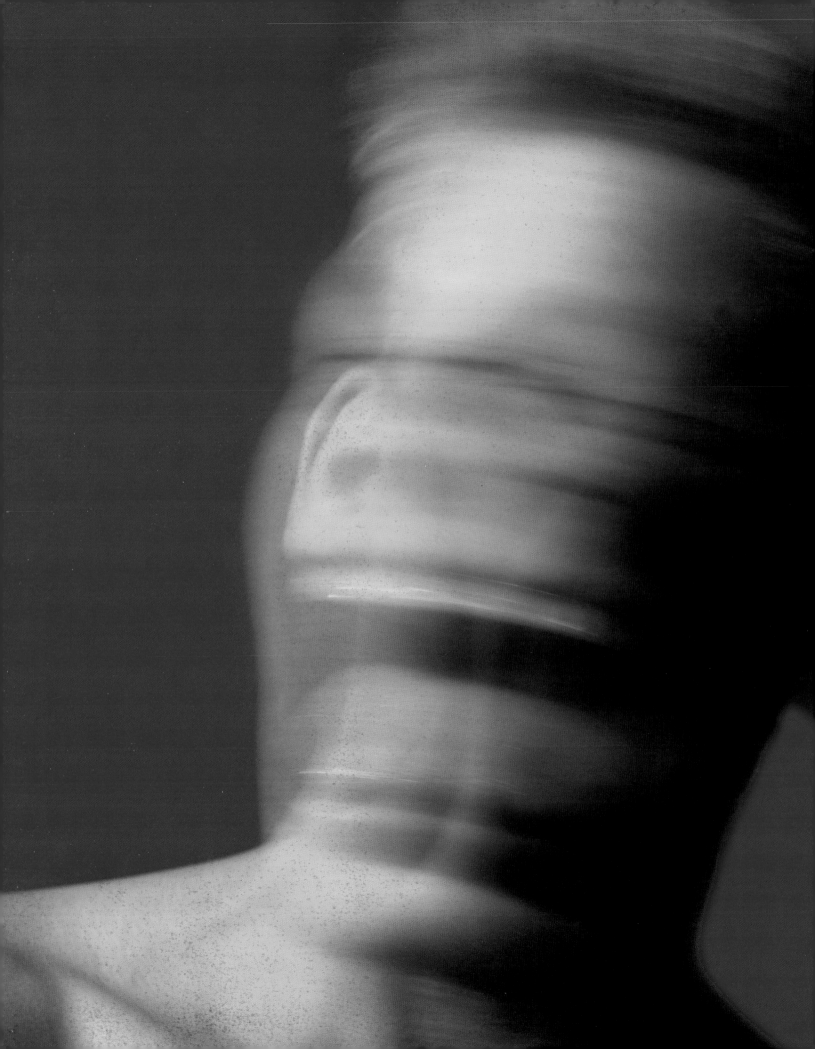

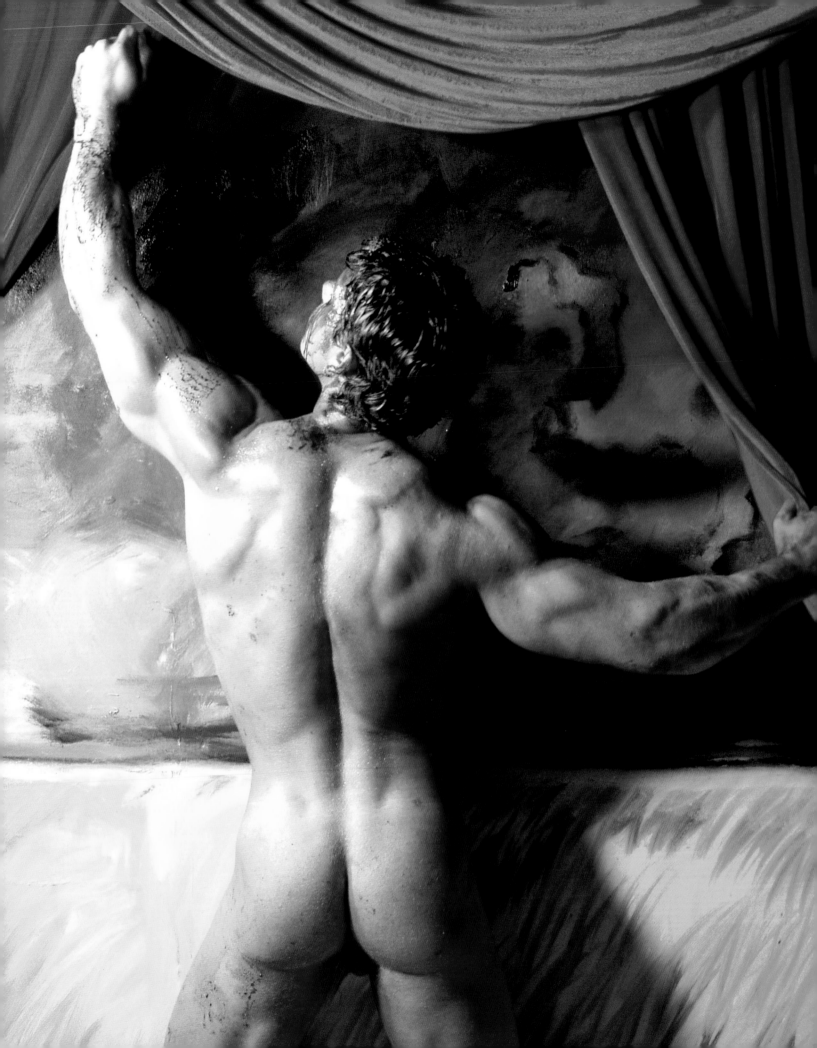

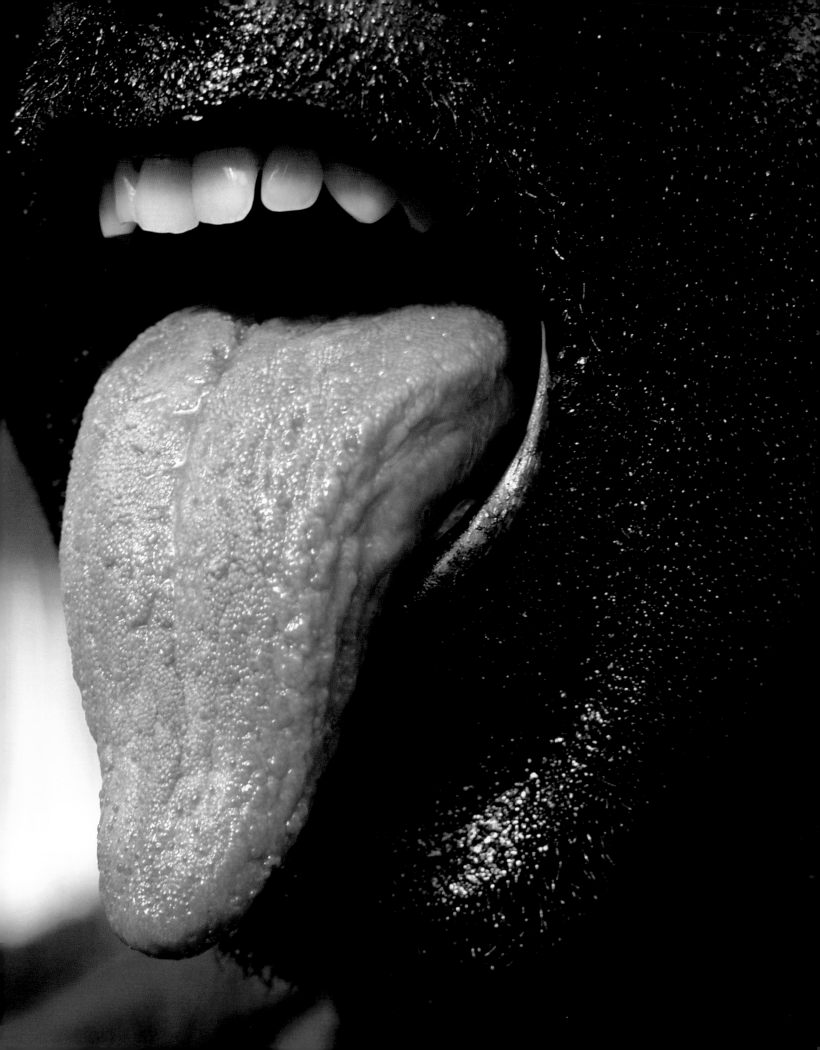

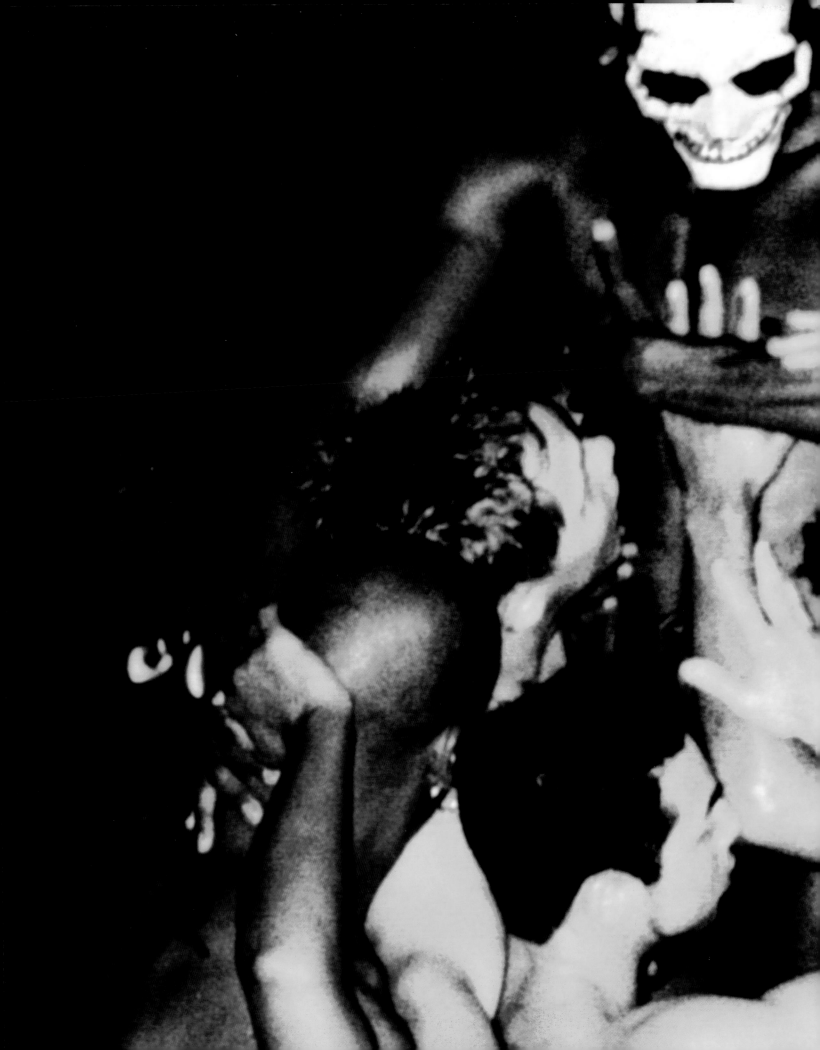

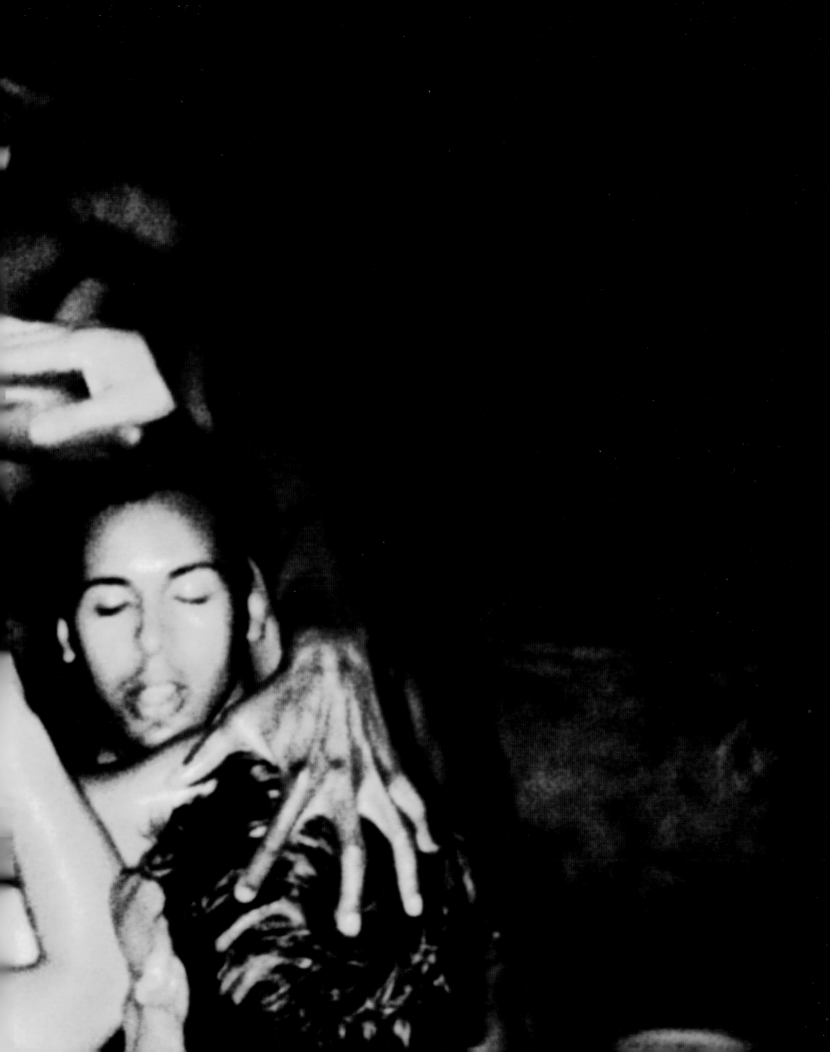

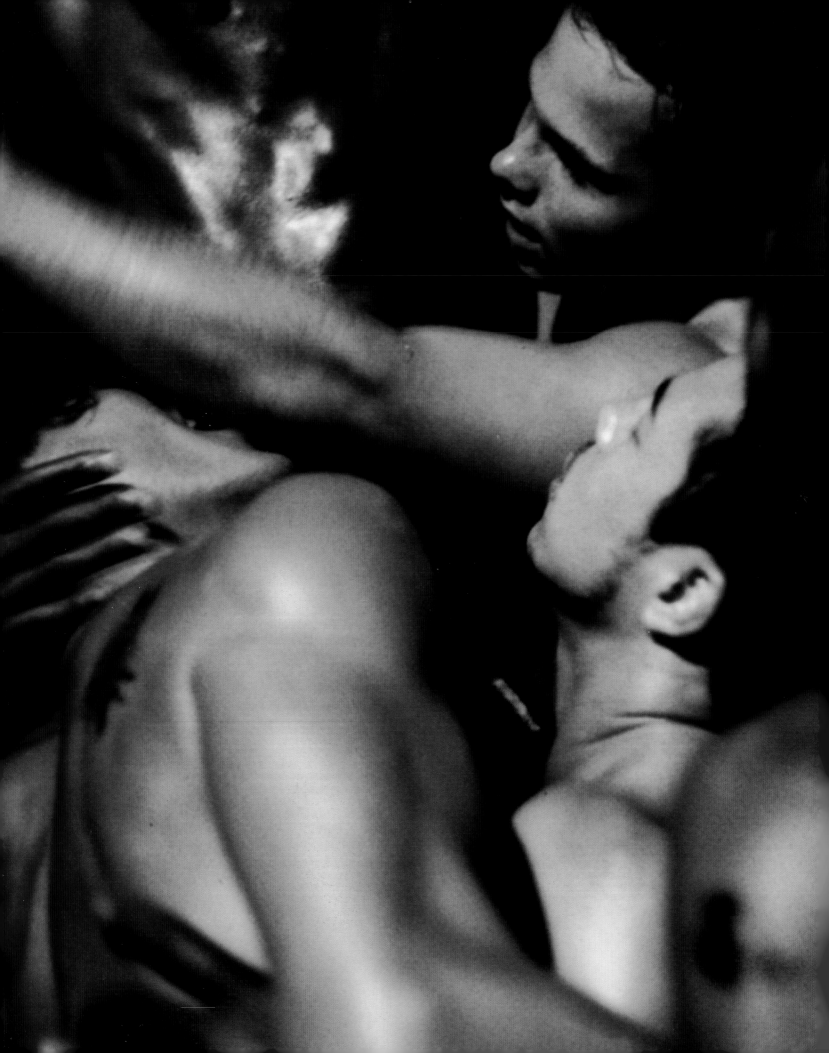

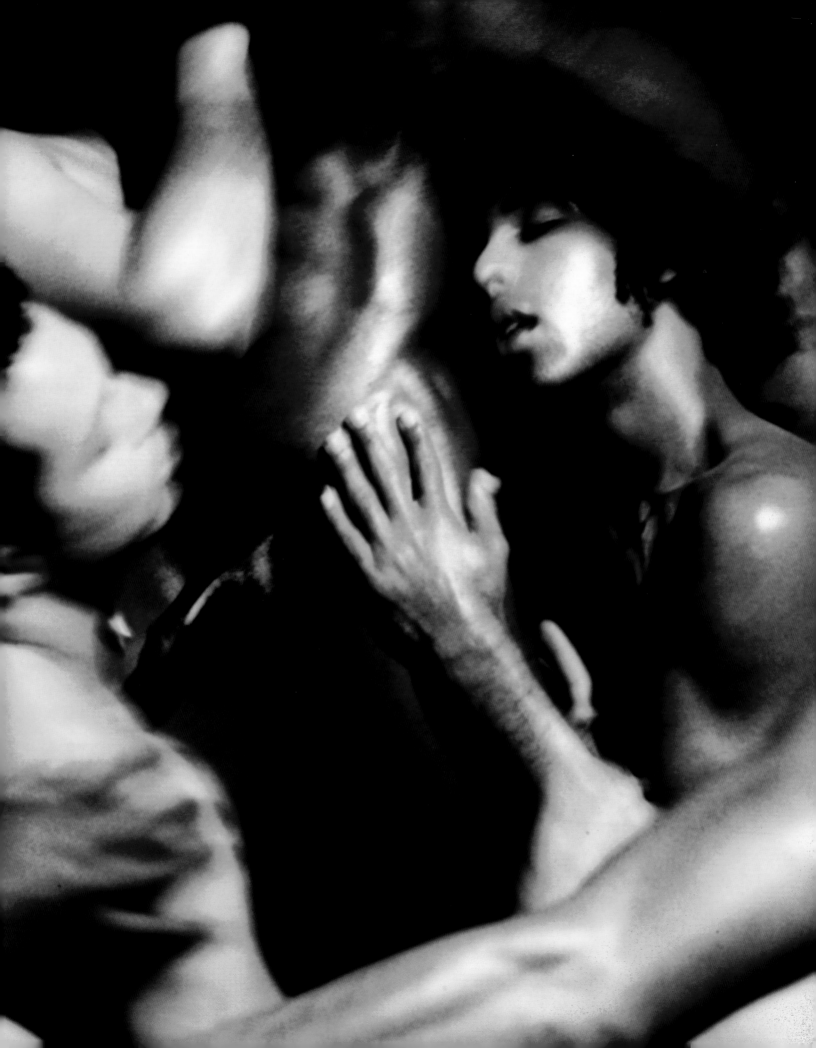

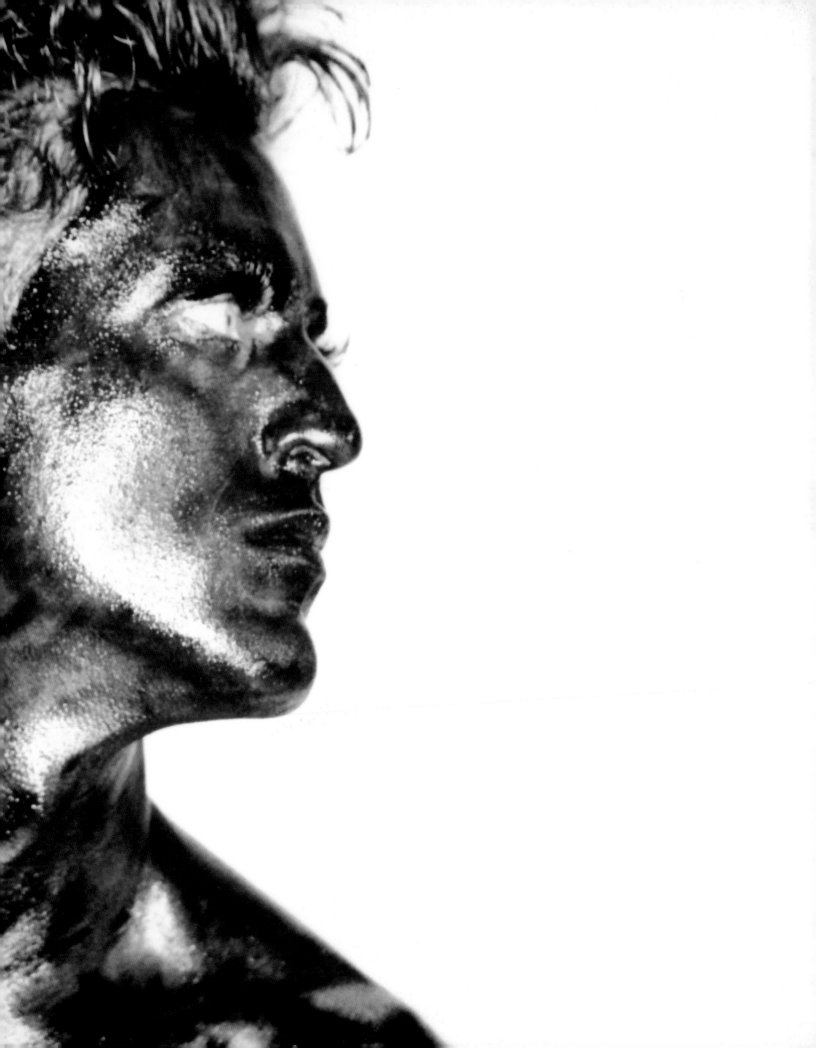

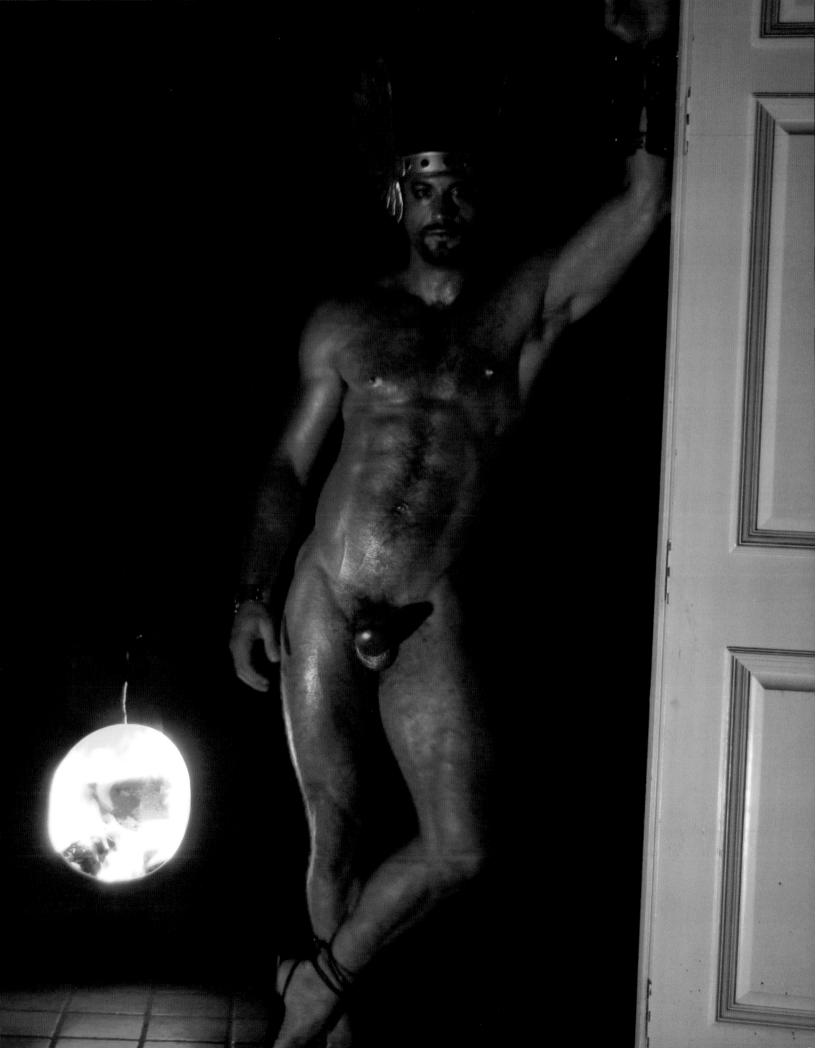

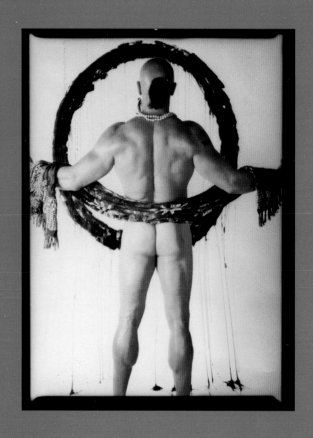

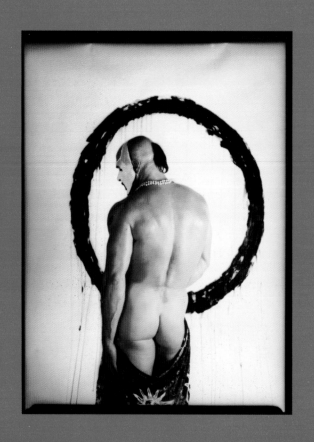

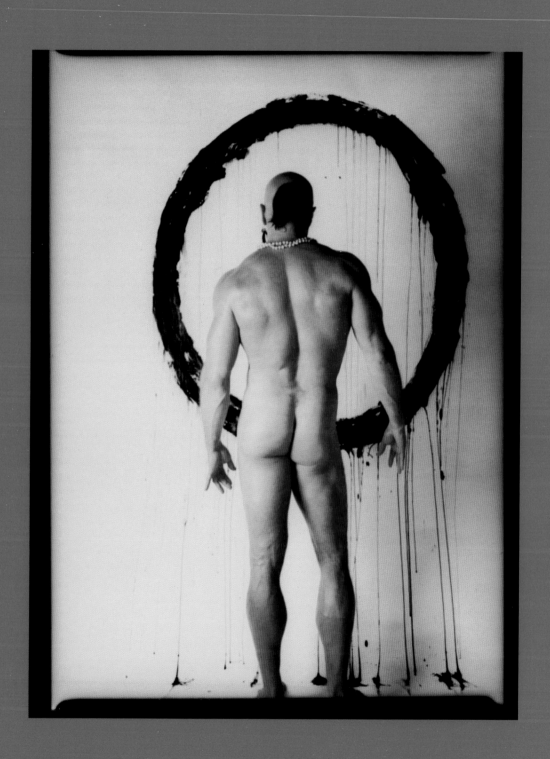

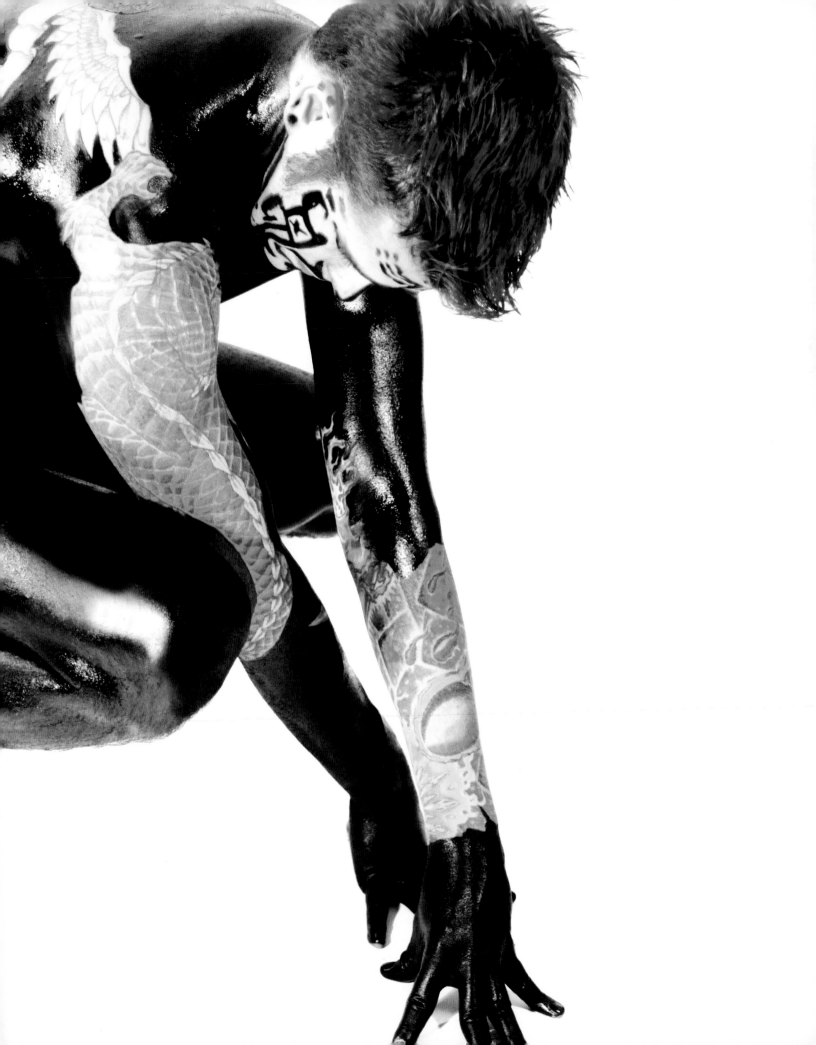

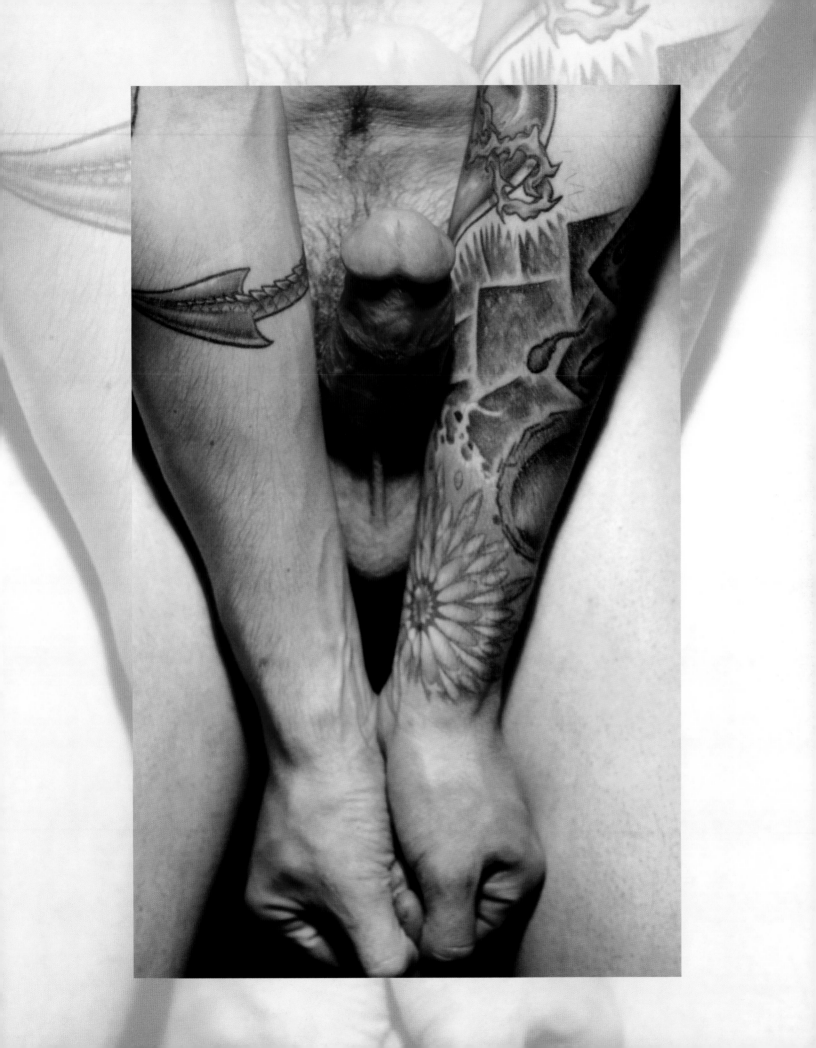

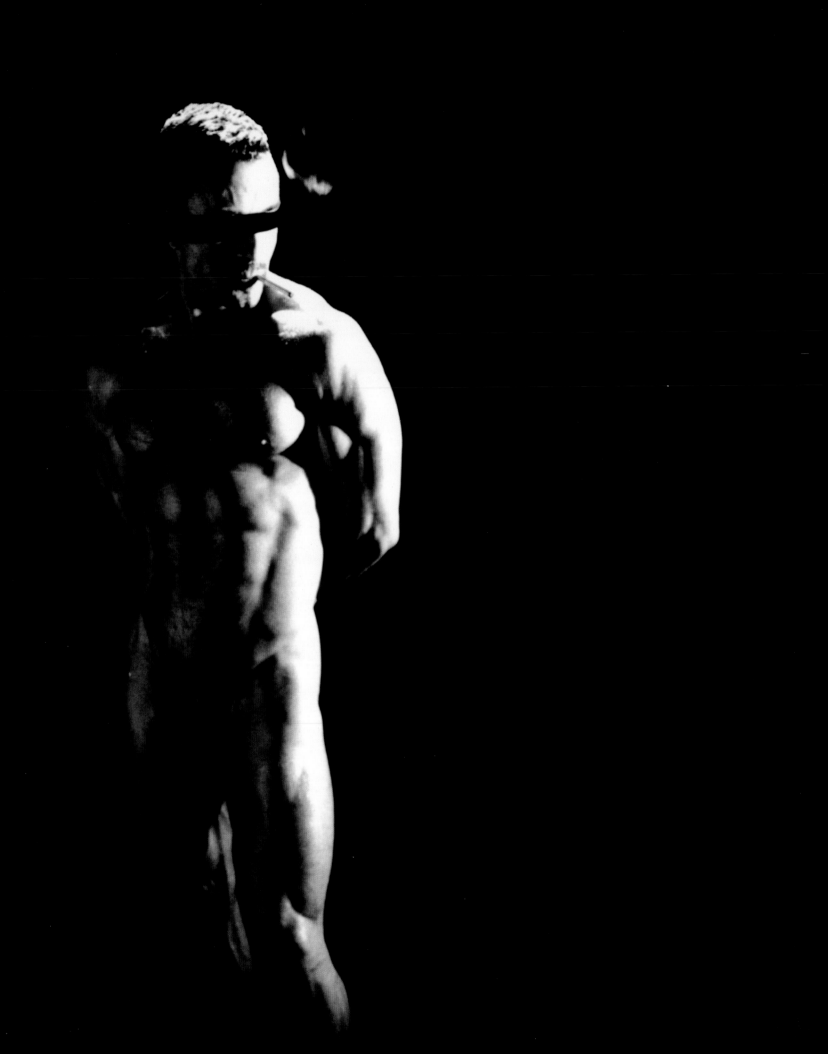

No hope of light.

Which would you prefer, sweet?

Eternity and indifference,

Or the fragile beat of love

In the face of our finality?

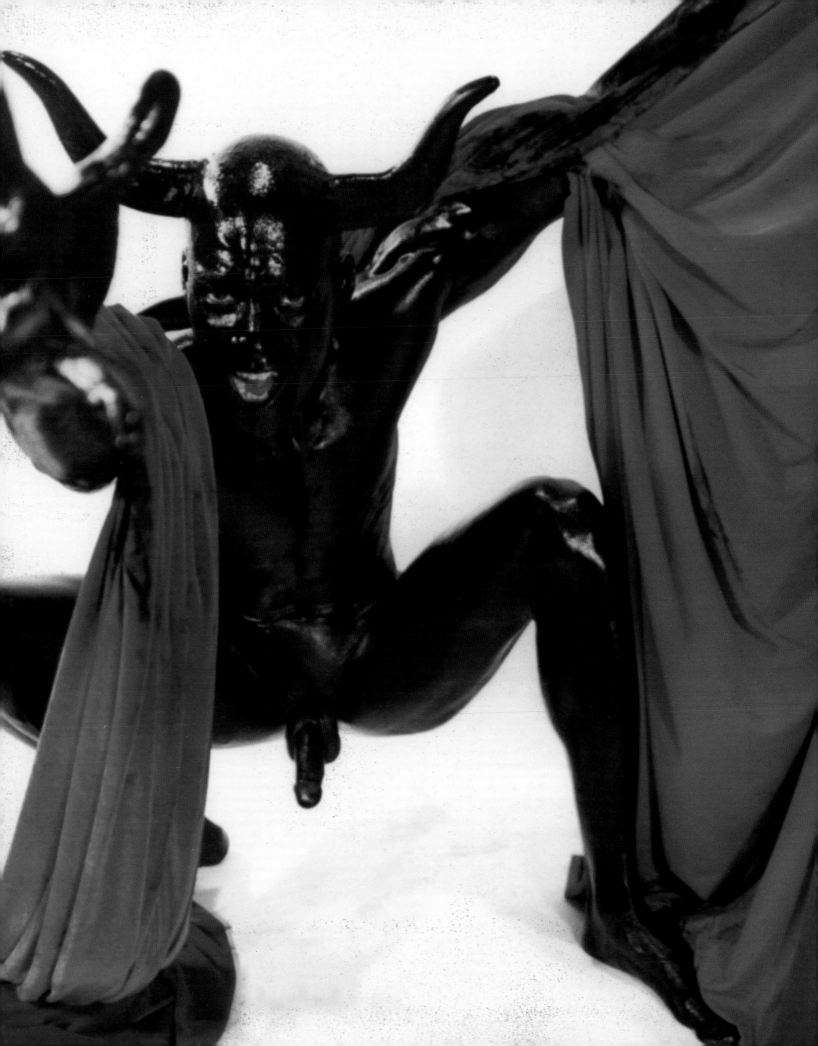

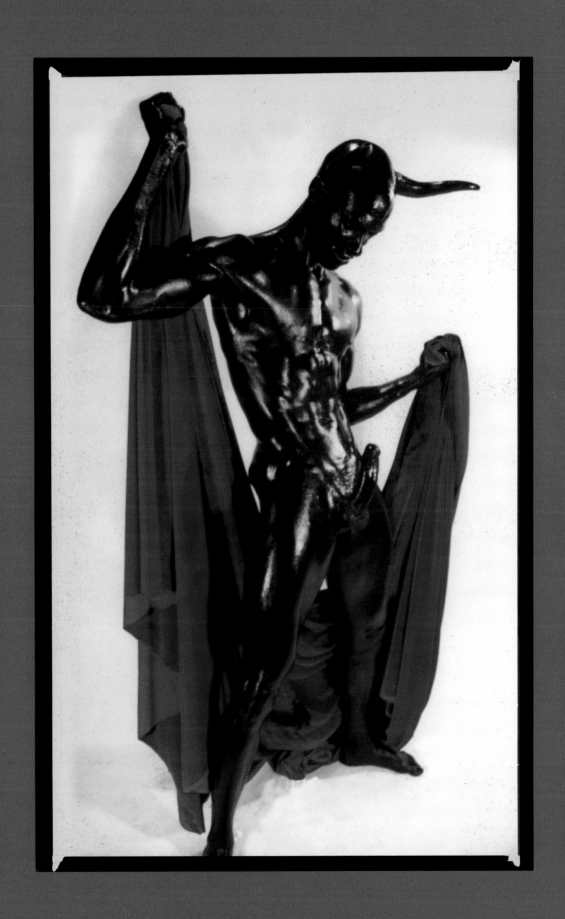

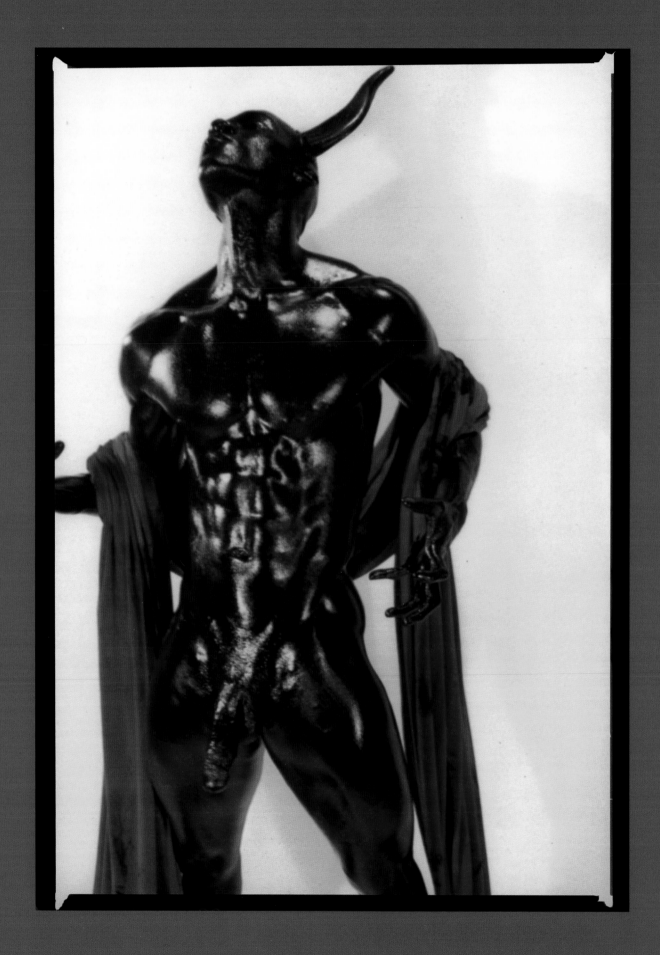

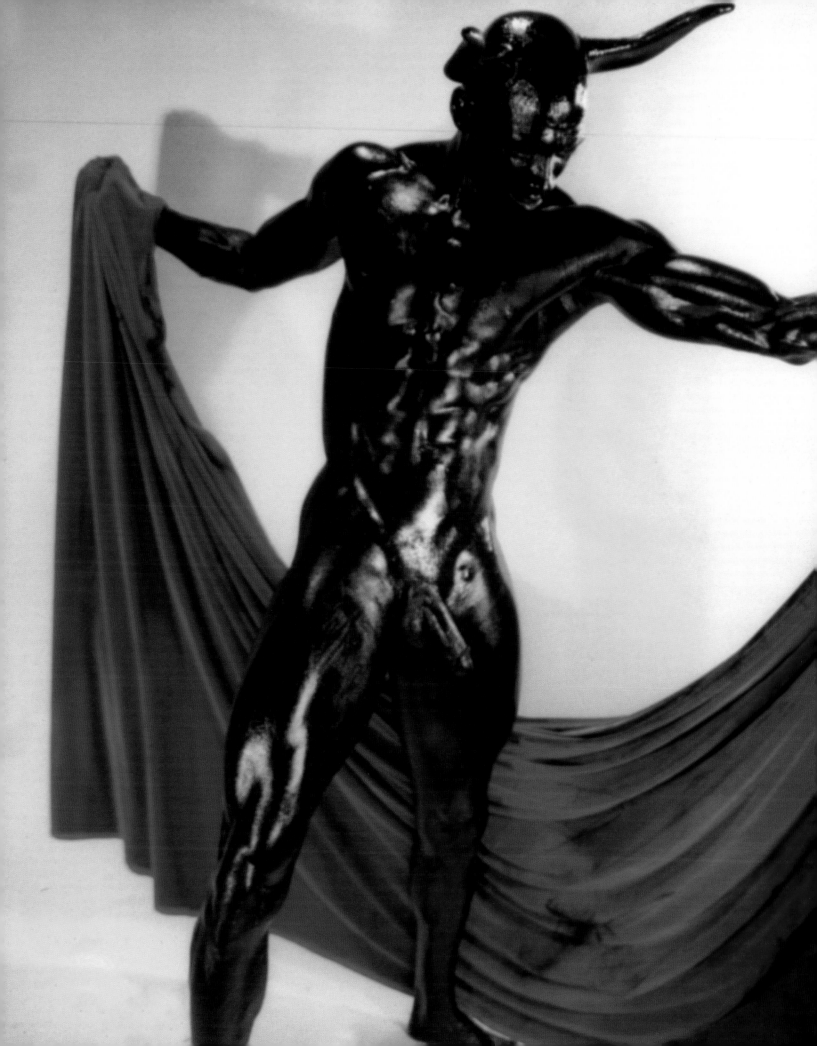

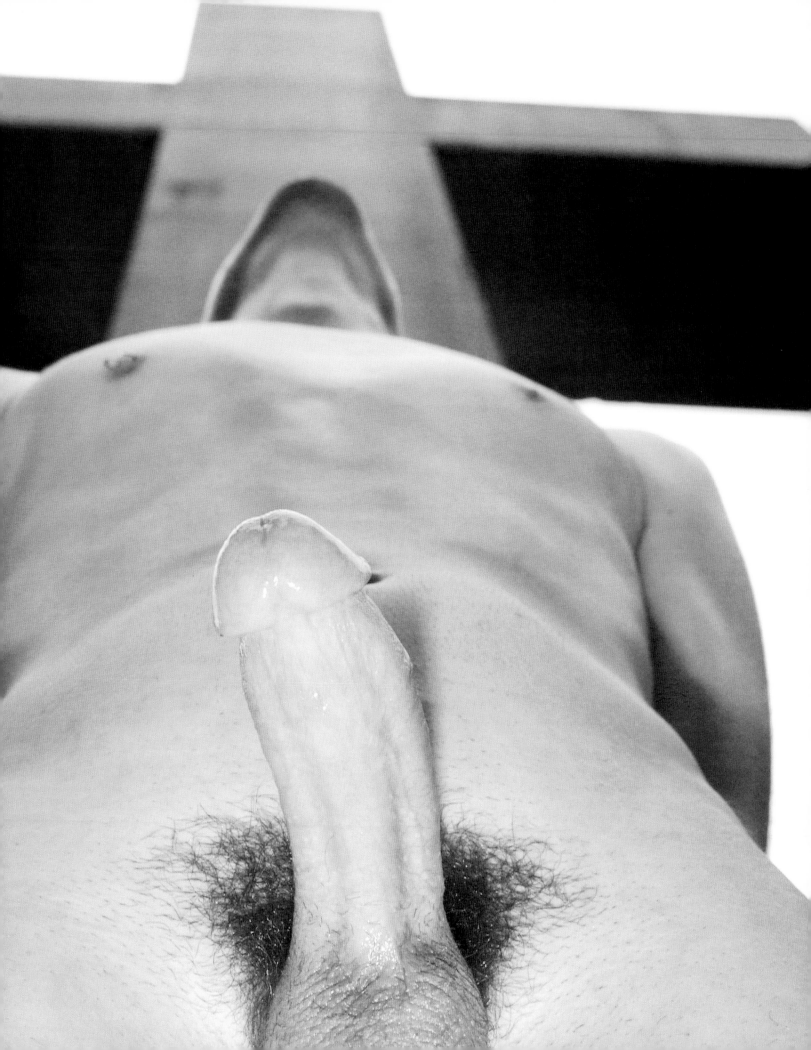

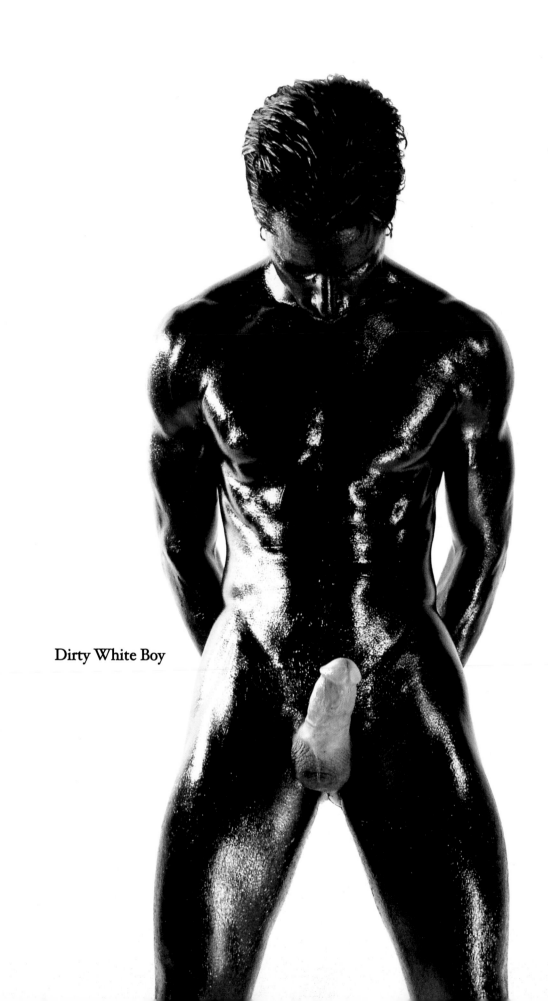

Dirty White Boy

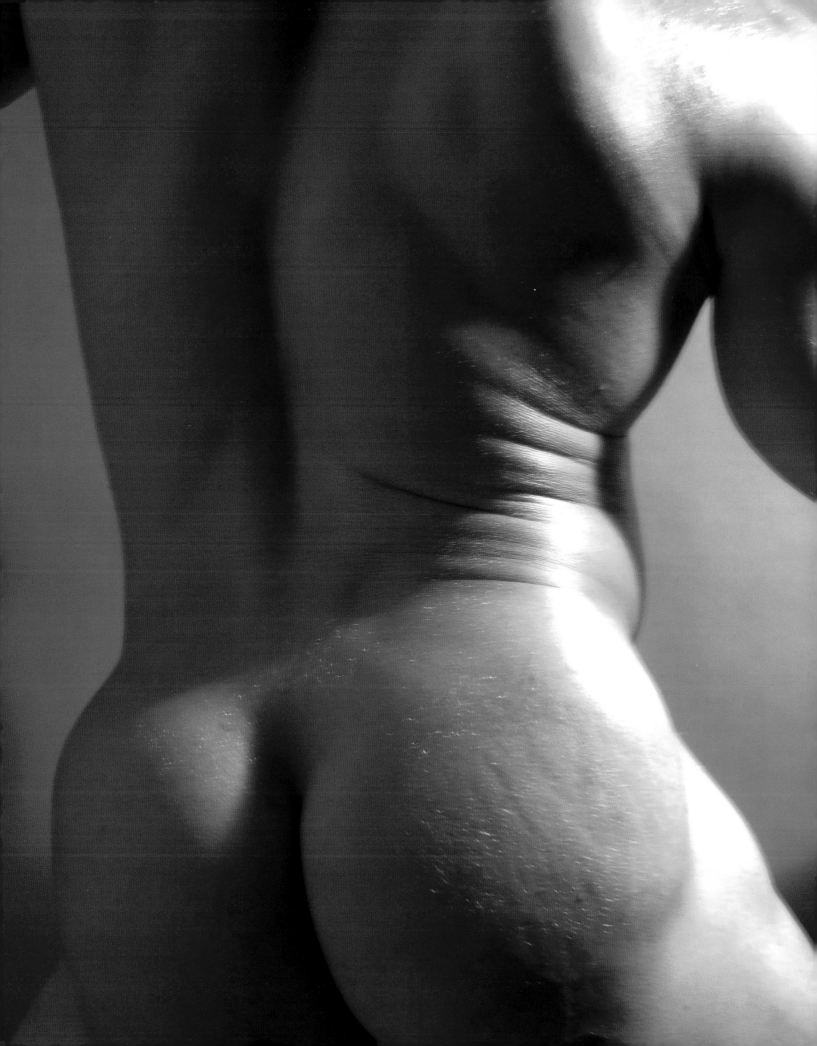

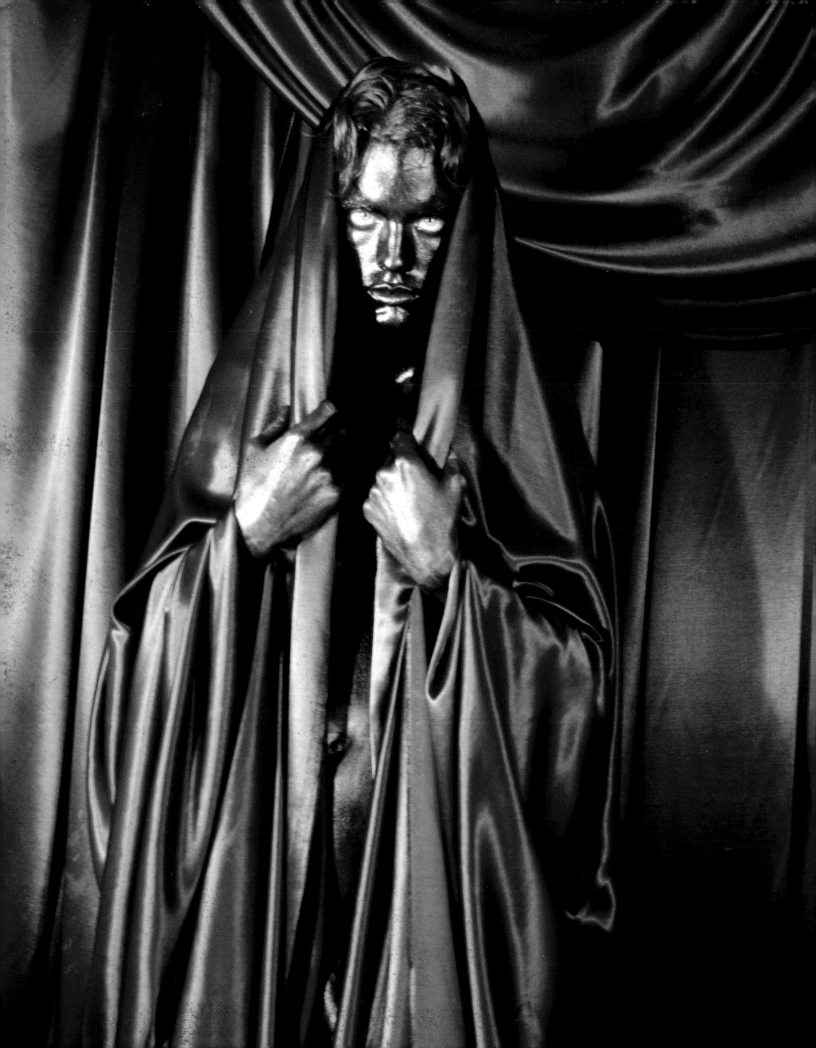

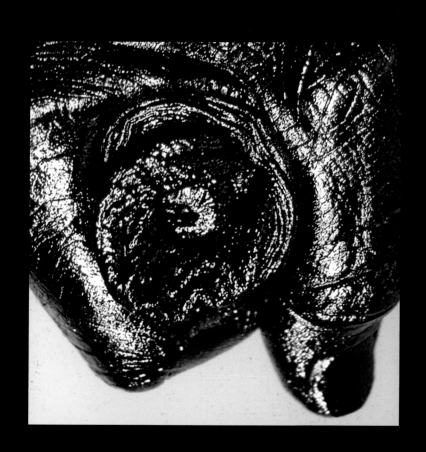

Brother Plato, right or wrong,

Says the tribe where I belong

Is a family of souls in two:

Me a half; another, you.

Let's stay together; one, tonight,

And prove our Brother Plato right.

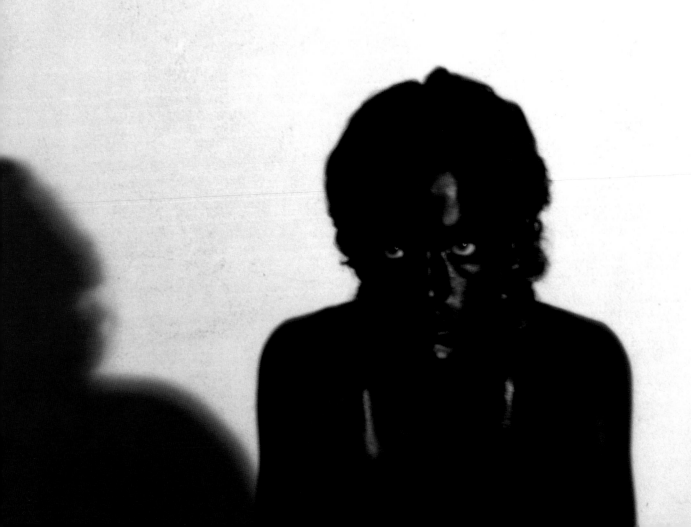

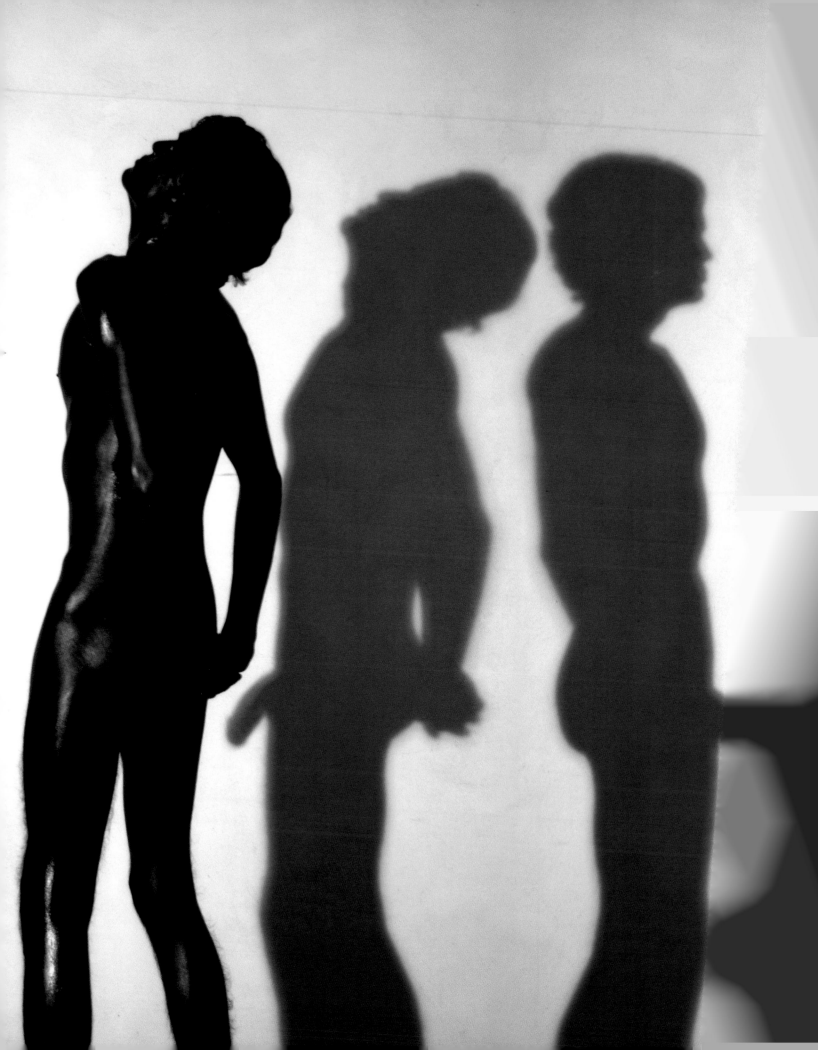

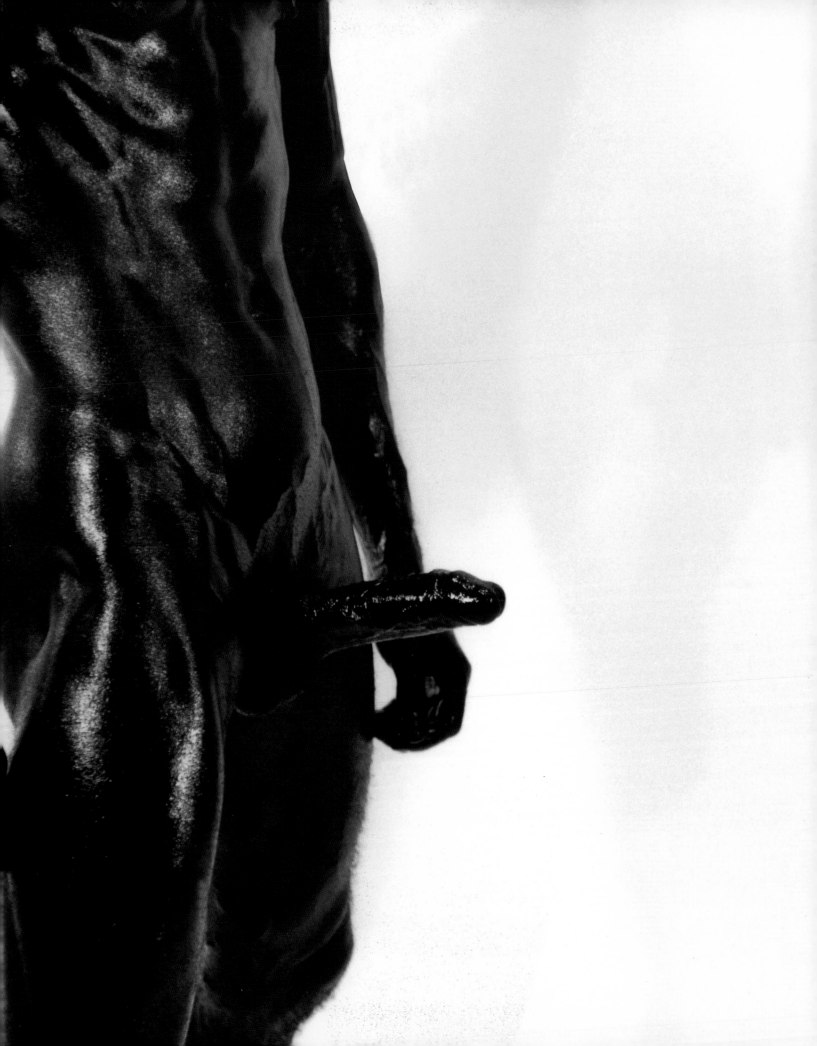

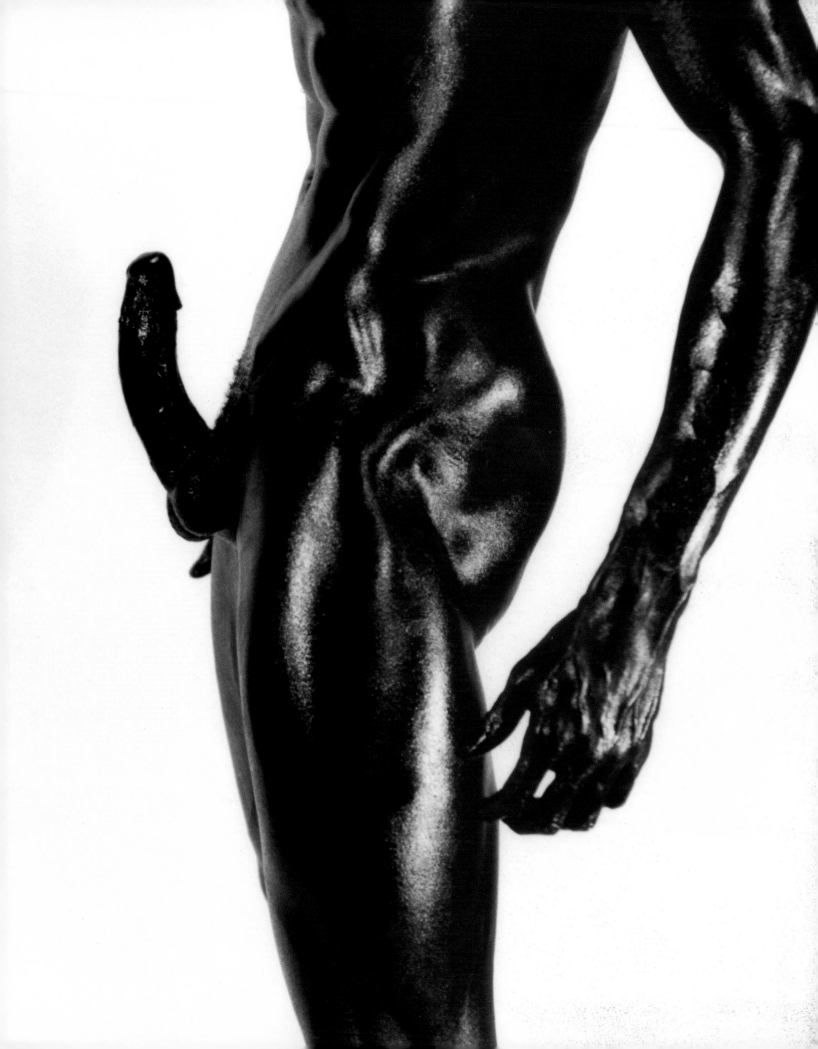

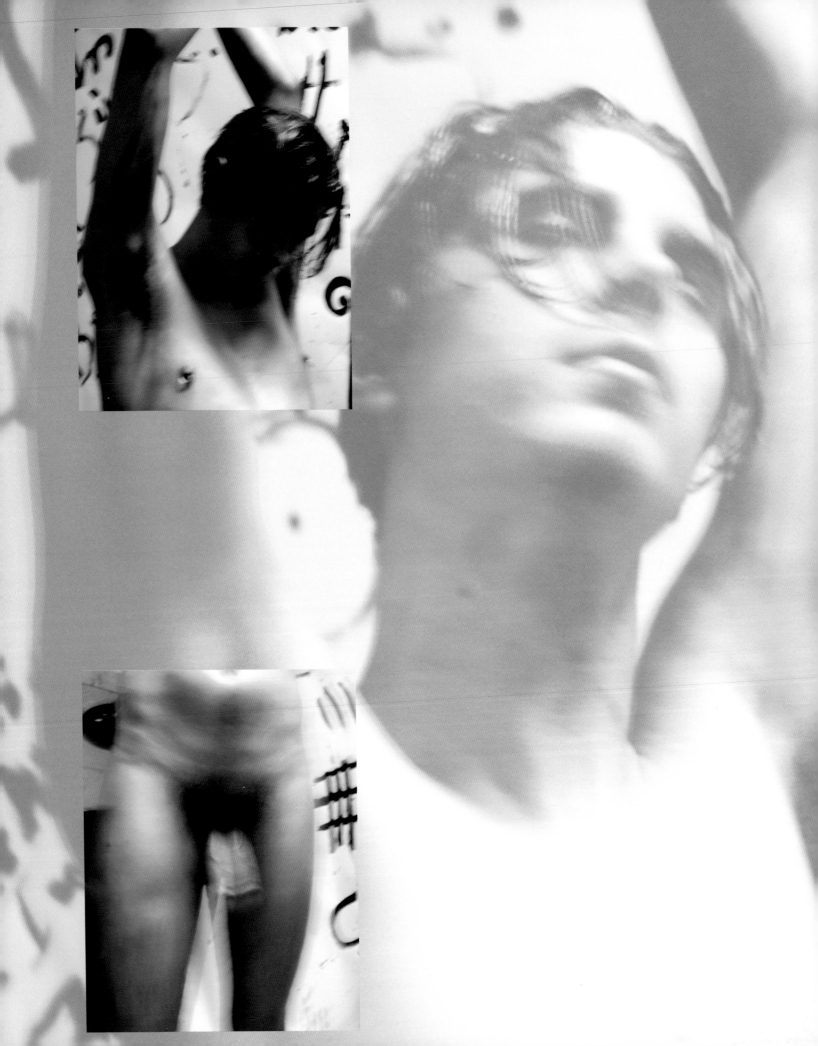

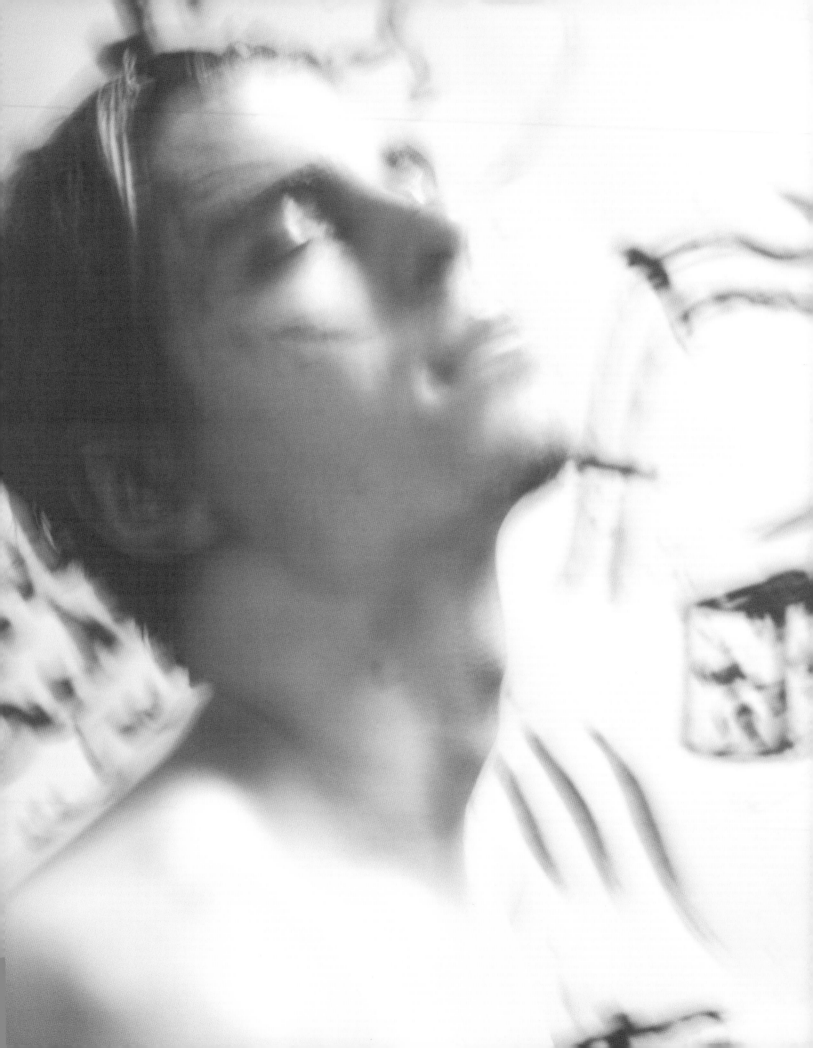

Your life is shit?

Well, so is mine.

They served us water

Instead of wine;

The bread is stale,

The cake has mold,

And worst of all

We're looking old.

But friend, we live,

And that's a lot.

So thank the Lord

For what we've got.

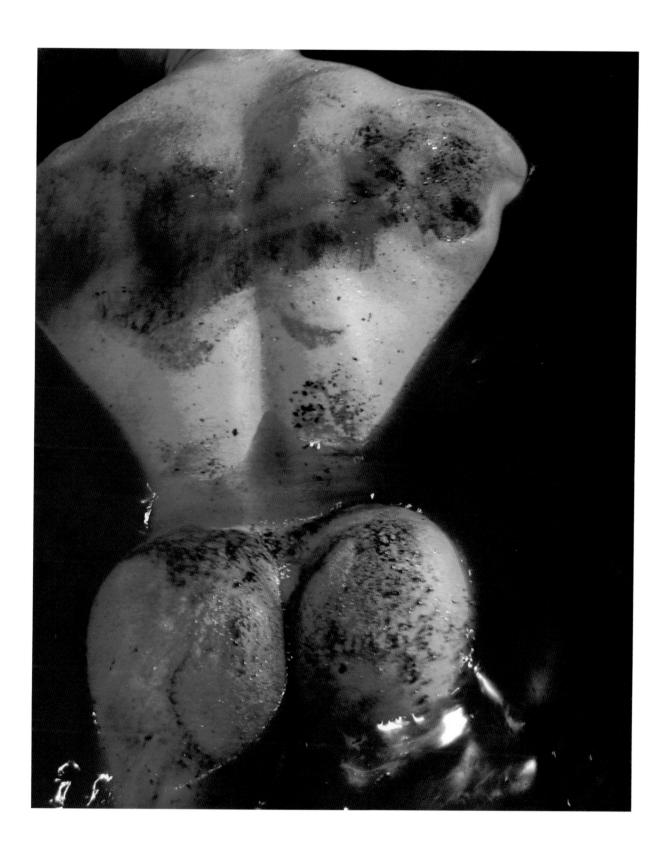

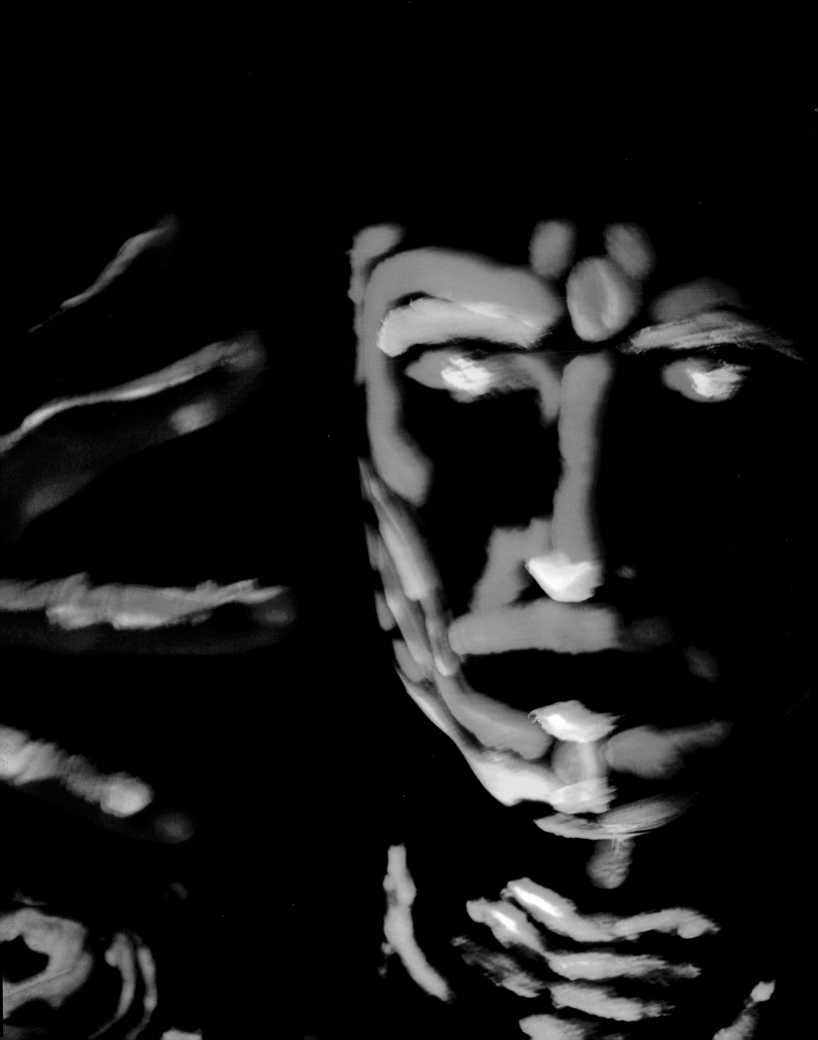

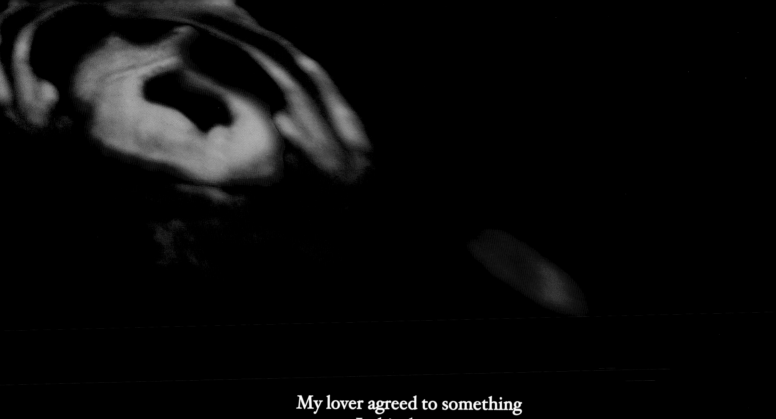

My lover agreed to something
In his dreams.
He murmurs affirmation,
His breath warm against my face.
I am in love with his yes.
As he sleeps.

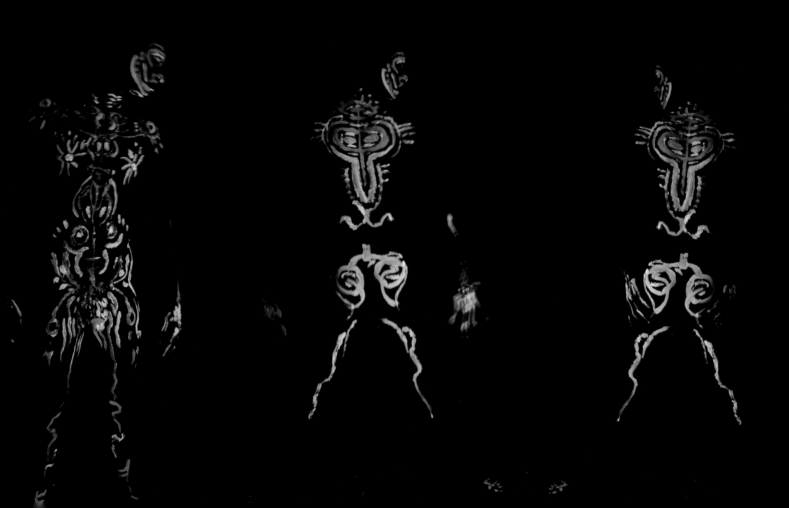

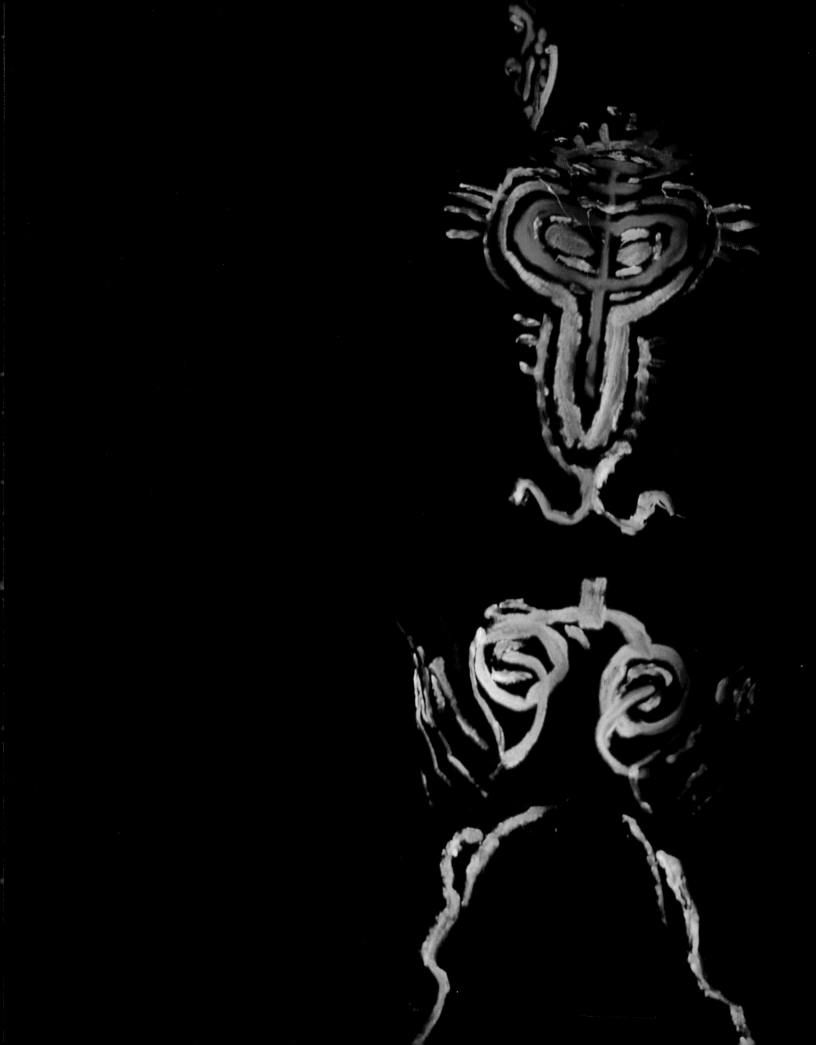

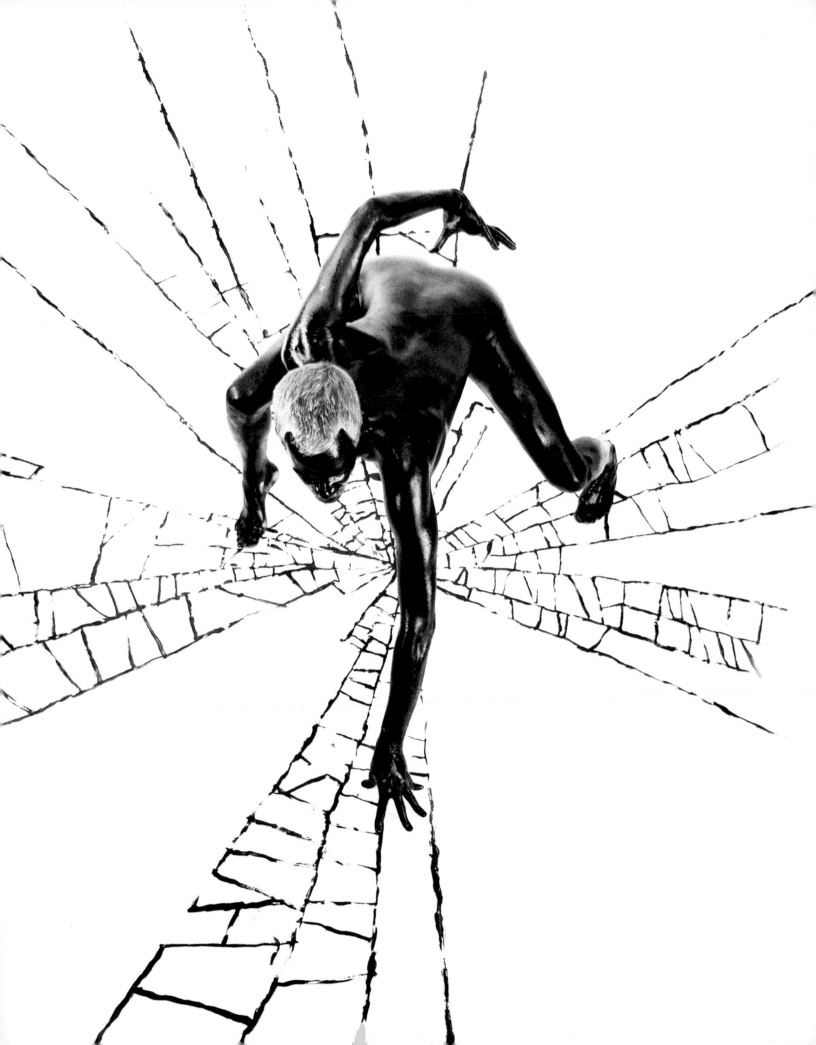

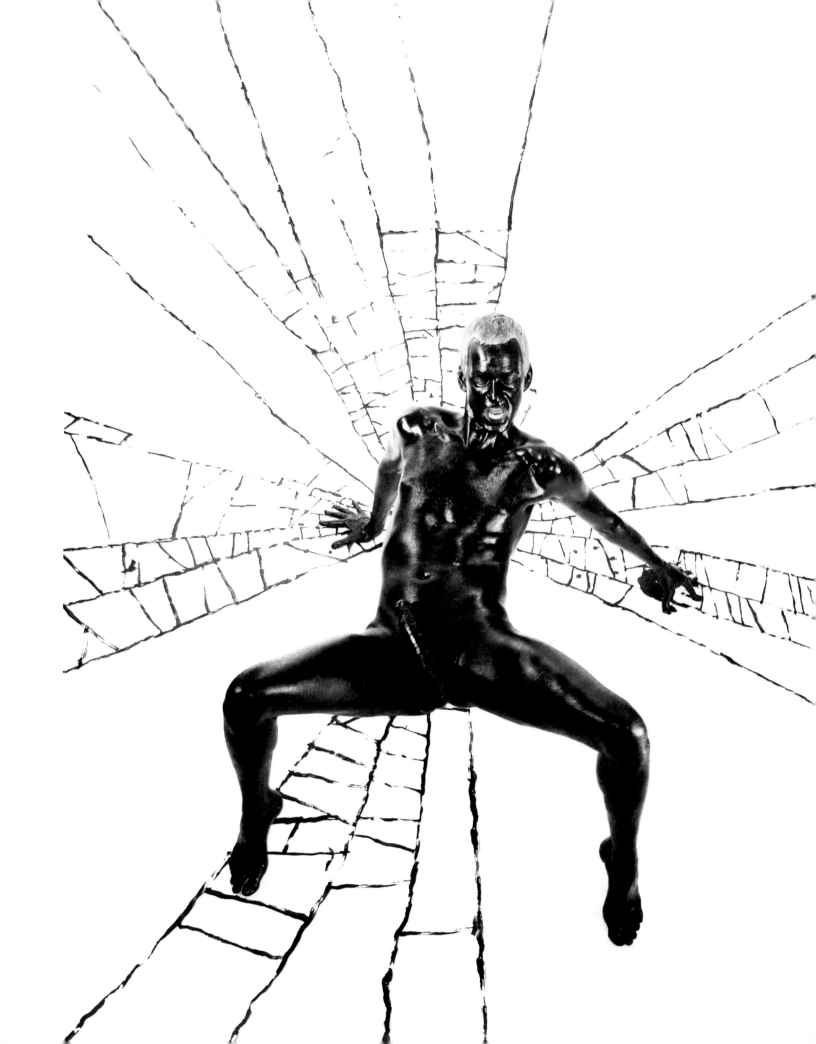

Existence

is just

a Möbius strip

with Love

scrawled on one side

and Death

upon the other.

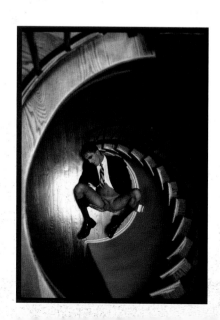
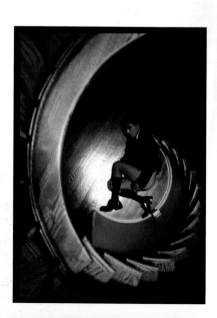

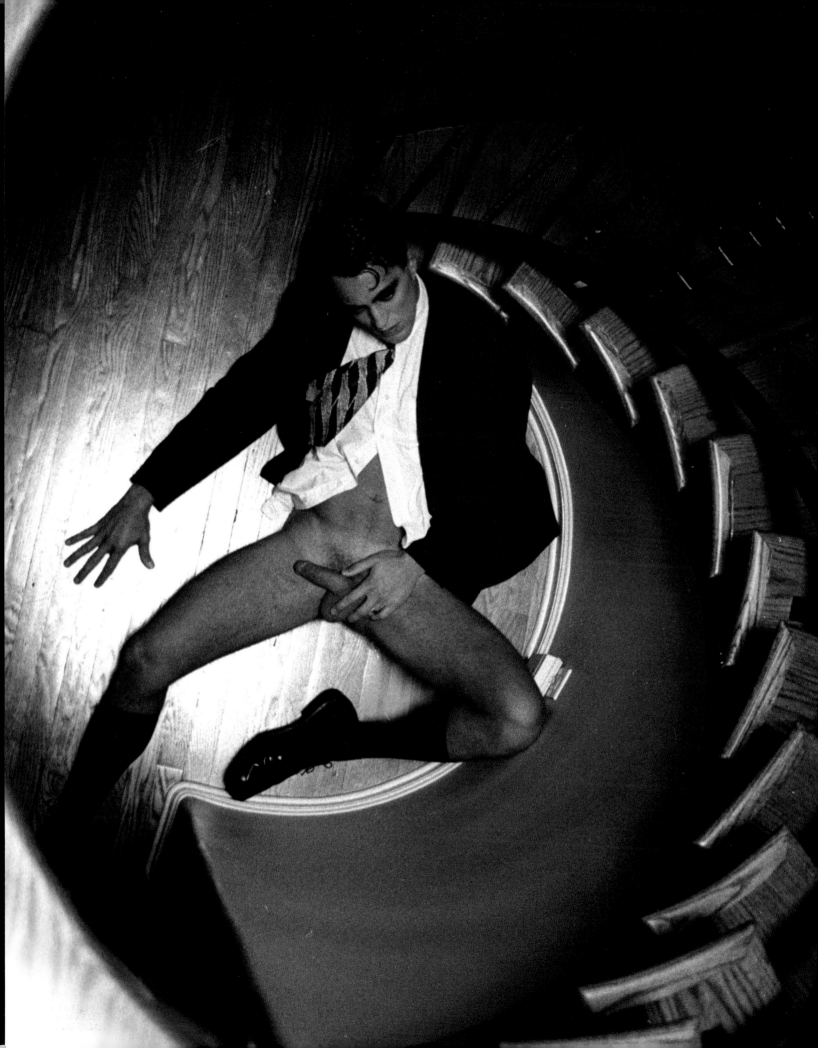

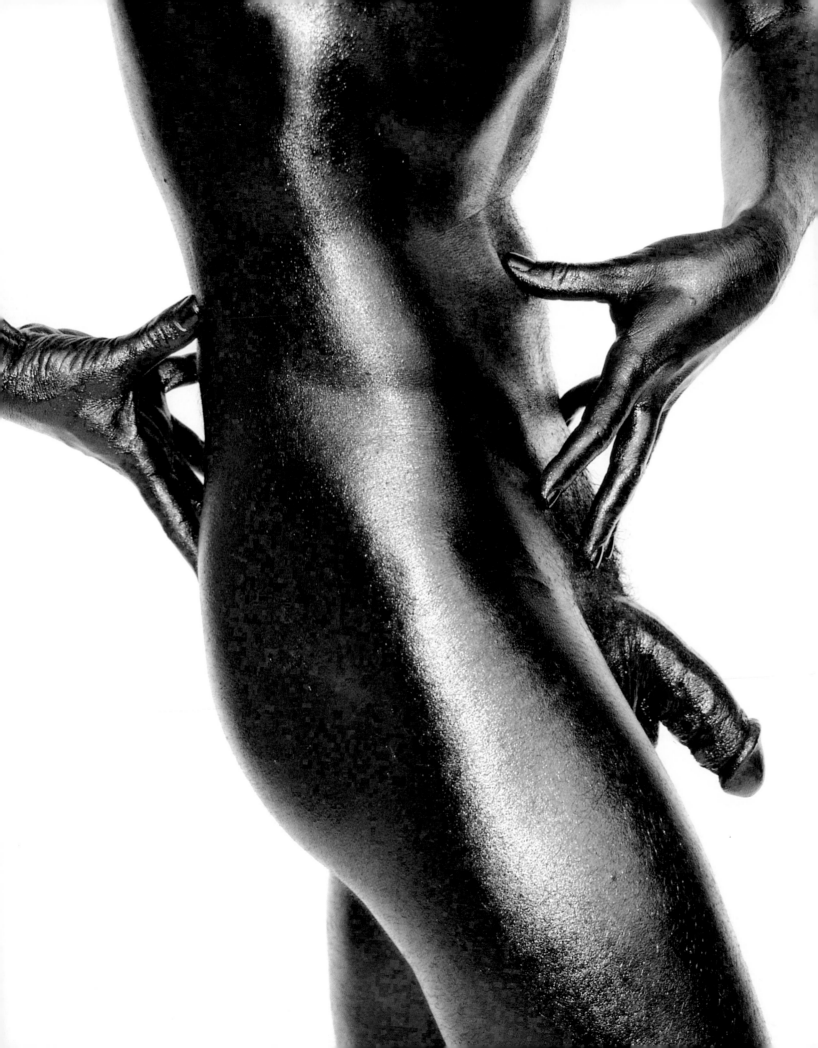

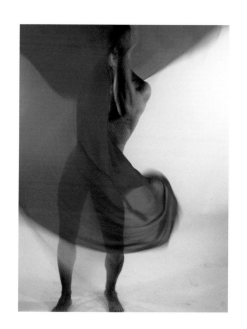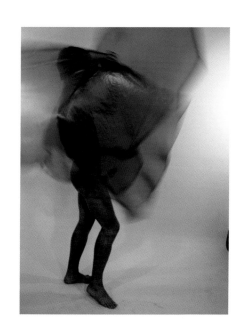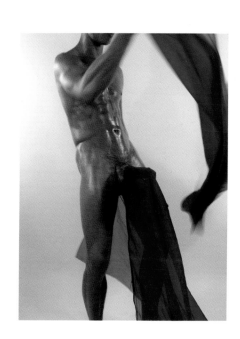

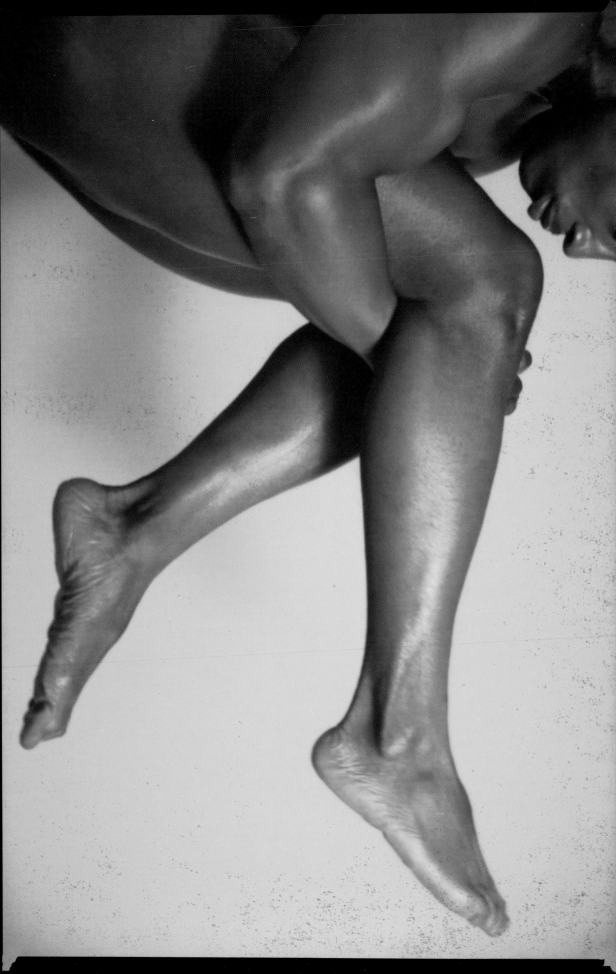

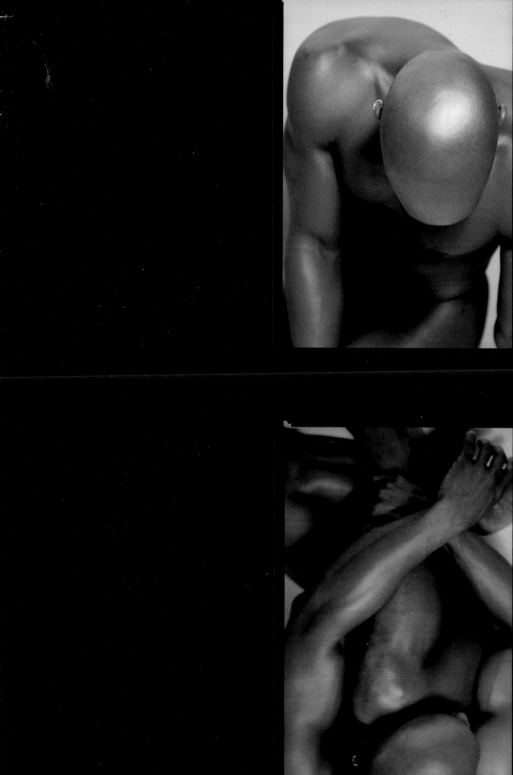

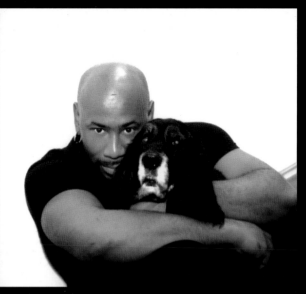

David Armstrong with his longtime companion, Bart, 2002

The author would like to acknowledge the contributions of the following people, without whom this book would not have been possible: Paul Alvarado, Teri Beasly, Noah Bishop, Robin Blackburn, Renata Bovara, Carlton C. Brunner, Kathryn M. Canino, Michael J. Clarke, John D. Cordova, Joe Cowan, Courtney Cruz, Alex Delasario, Daniel Delgado, Eric Eichelberger, Nick German, Andrew J. Goebel, Michael Hadley, Jim Hamner Jr., Robb Humphreys, Maurice Irvin, Michael Izzo, Niles Jenson, Michael Jones, Kelly Kidd, George King, Jordan King, Jan Klasovity, Louis Klein, Benjamin Kozub, Steve Kulig, Eric Lavoy, Chris Levitino, Jason Ling, Gary Little, Bogar Martinez, Tony Mason, Donald McCathrion, Dennis P. McLain, Victor Mendoza, Matt Miller, Michael Phillips, Tim Phoenix, John Poncé, Larry Sands, Boris Schaak, Marc A. Shamus, Chris Shorty, Glen Soukesian, Bobby Sun, Gene Sweeney, Heather Tanis, Dee Teixera, Peter Tiefenbach, Tommy, Micah Uchiyama, Tony Vasquez, Henning Von Berg, Rob White, Loren P. Wilson, Dirk Wolter, Andy Zeffer, and Fabian Zenneti.

First published in the United States of America in 2003 by
UNIVERSE PUBLISHING. A Division of Rizzoli International Publications, Inc.
300 Park Avenue South, New York, NY 10010 www.rizzoliusa.com
Distributed in the U.S. trade by St. Martin's Press, New York
Photographs © 2003 David Armstrong. Text © 2003 Clive Barker
Design by Michael Hadley
2003 2004 2005 2006 2007 / 10 9 8 7 6 5 4 3 2 1
Printed in Italy
ISBN: 0-7893-0845-2
Library of Congress Catalog Control Number: 2002112183

White whiskered Bart,
The patriarch of our household,
Died this morning,
Just a few days short
Of his nineteenth birthday.

He died in his sleep,
In the embrace of his master;
No doubt there could be no more
Painless passing.

And now we swap tales of him—
The shortness of his temper,
His love of pizza—
As though he were a man.

Perhaps he is, today.
Perhaps he was reborn
In the moment of his passing
Into the shape
Of a boy-child,
And is now seeing through human eyes.

But I don't think so.
I think he is enjoying
The high life in paradise,
And will not notice the time pass
Til we come to him,
So distracted is he
By the fun of snapping
At the heels of angels.